FOREST DEFENDERS

THE CONFRONTATIONAL AMERICAN LANDSCAPE

CHRISTOPHER LAMARCA

pH powerHouse Books Brooklyn, NY

For Sara, Robin, Debrae, and Stephanie: A gateway has been opened.

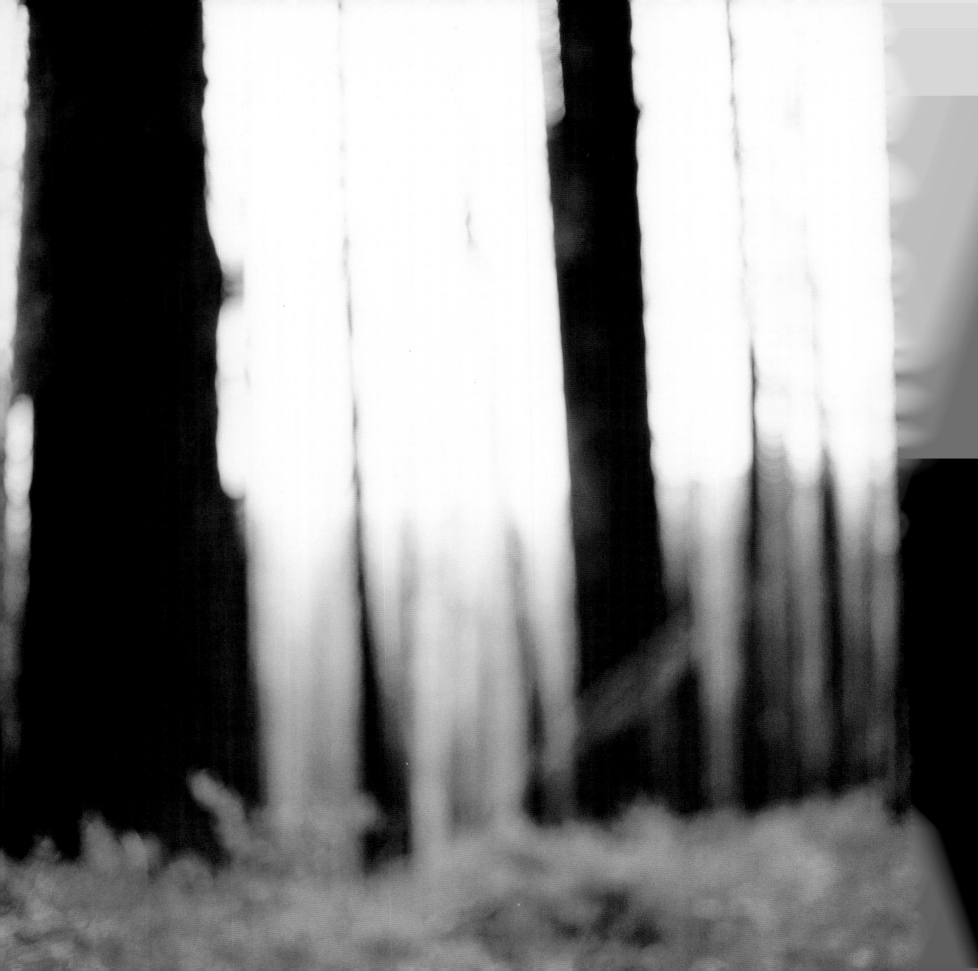

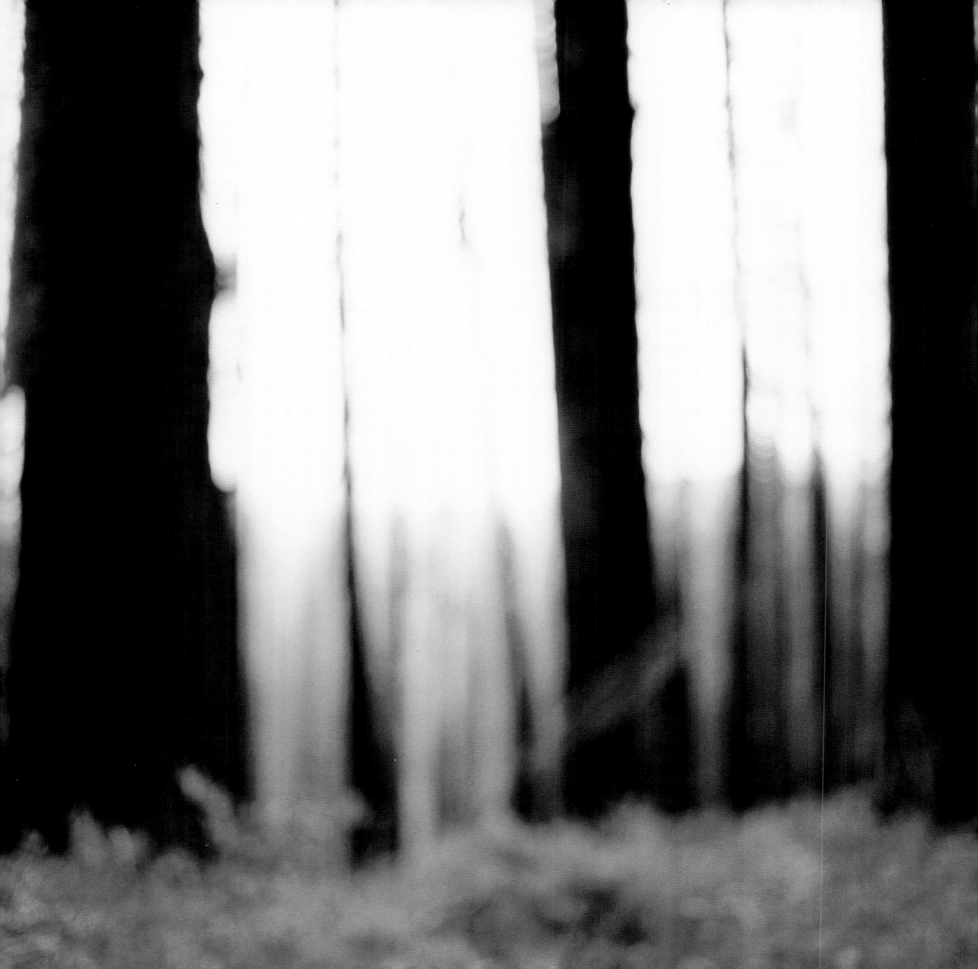

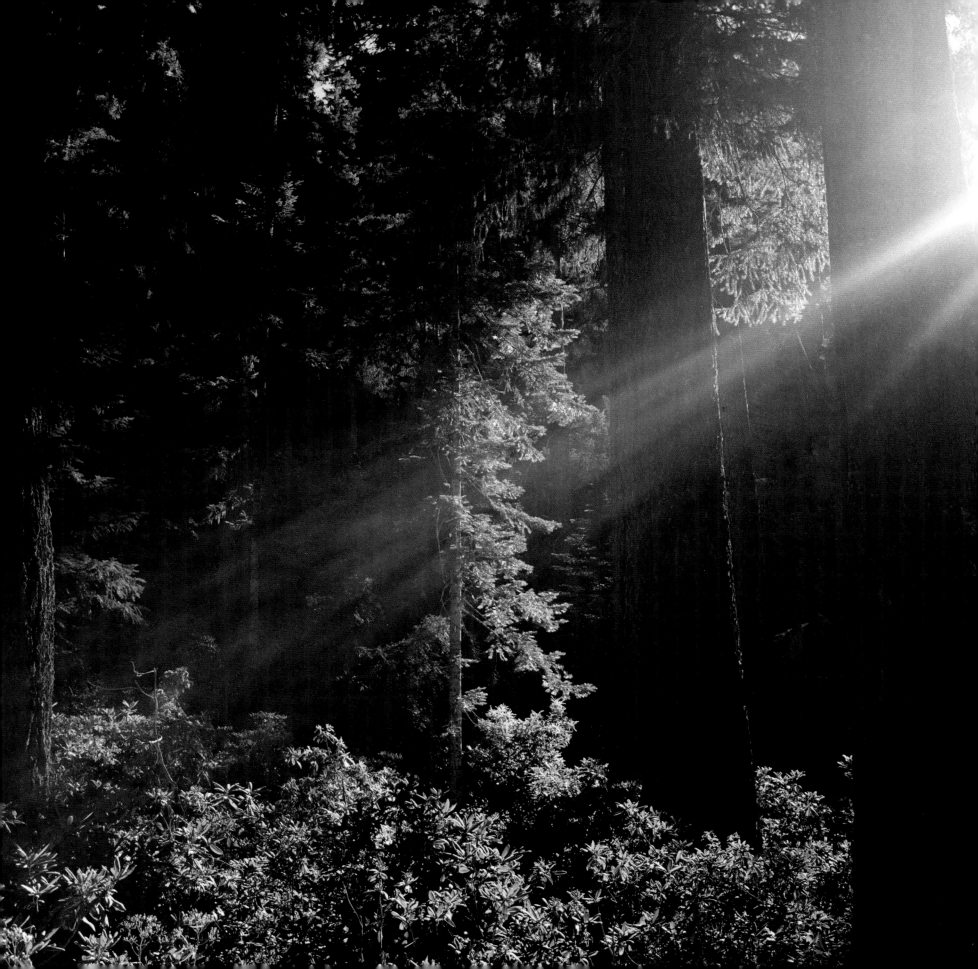

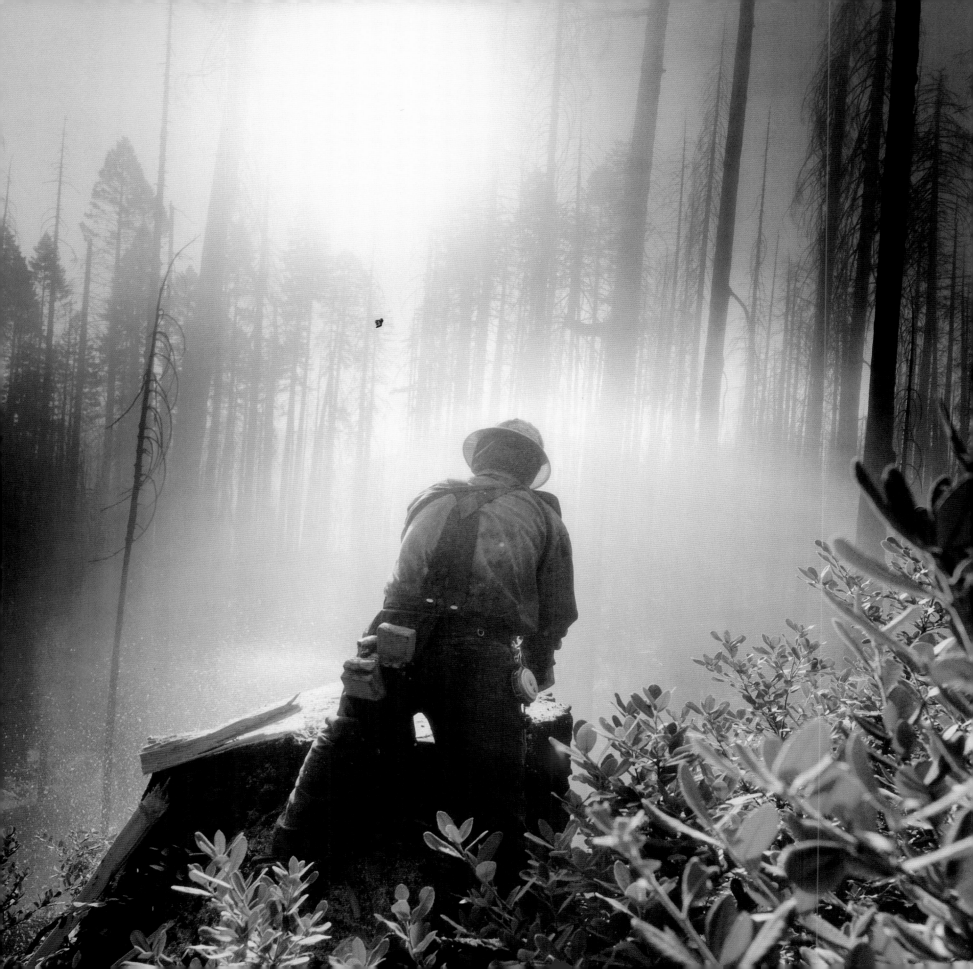

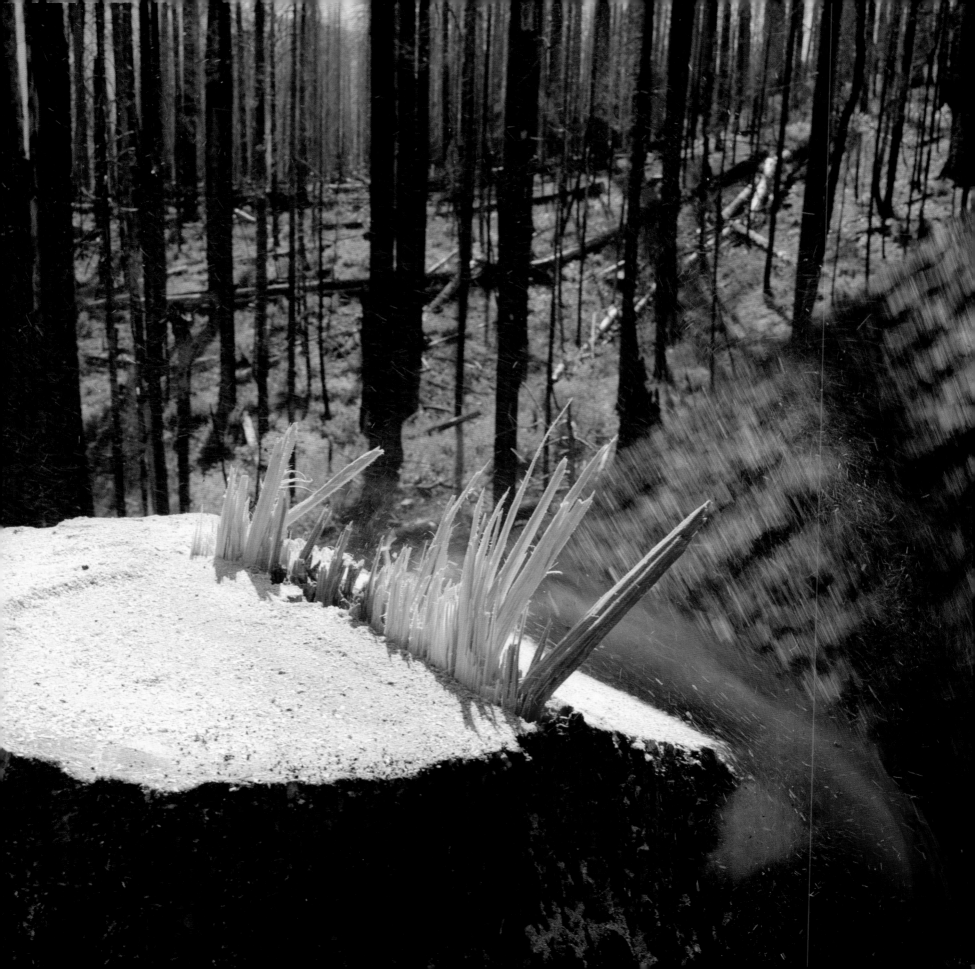

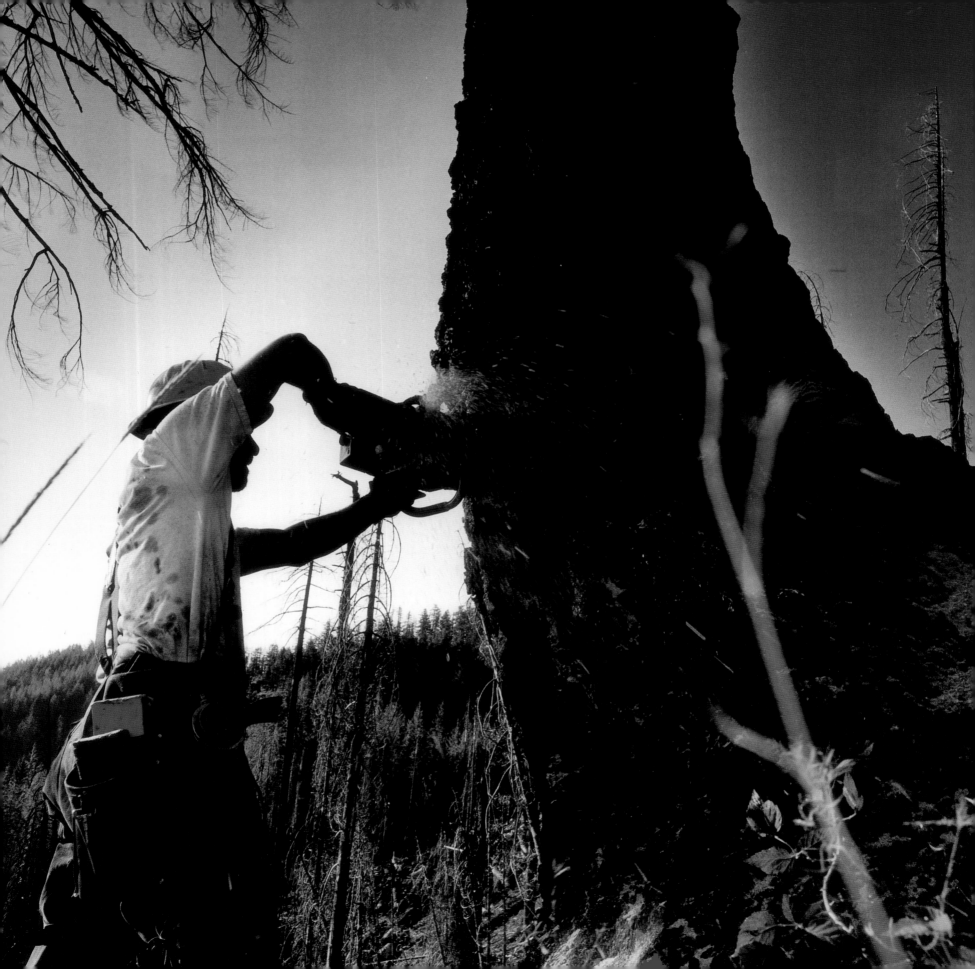

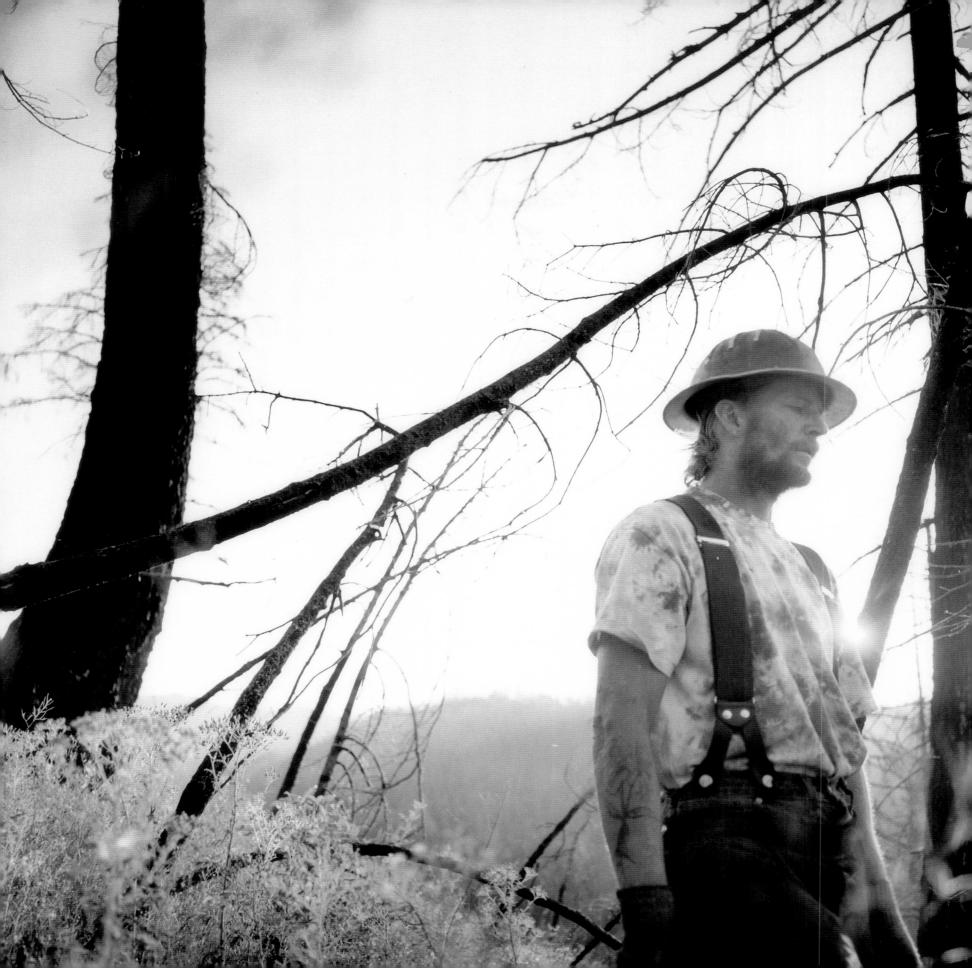

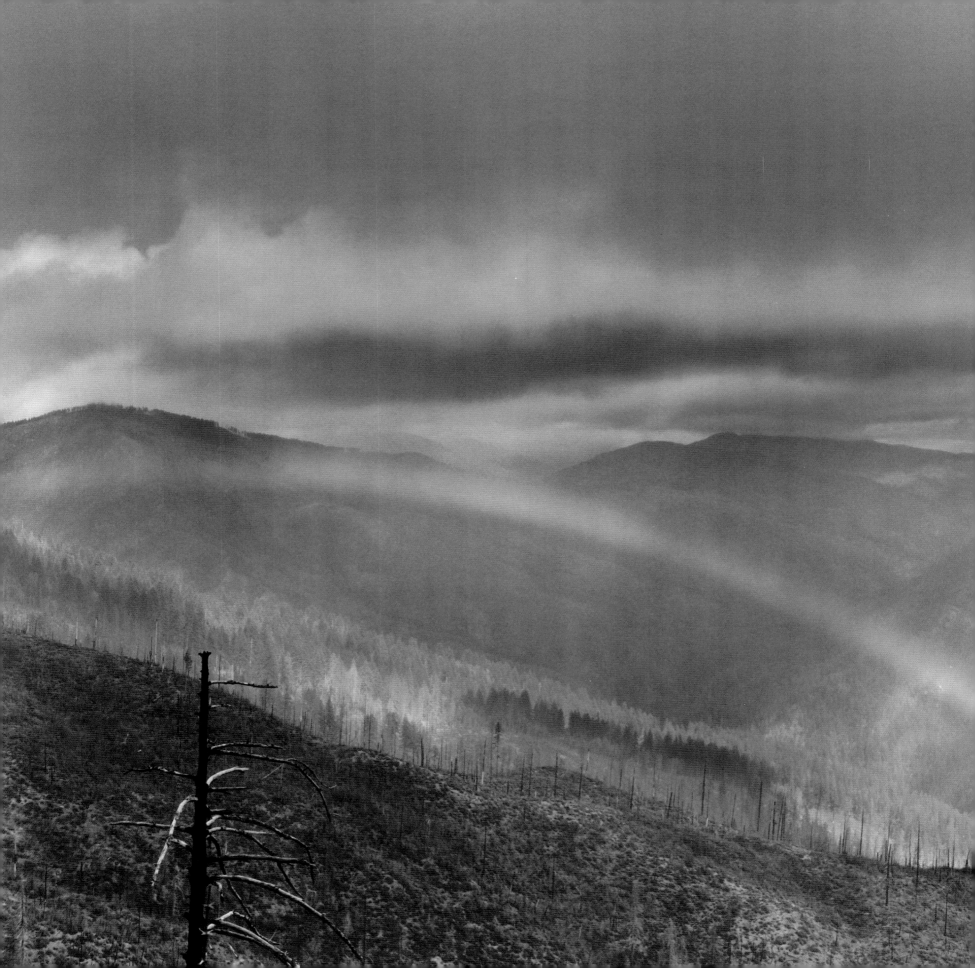

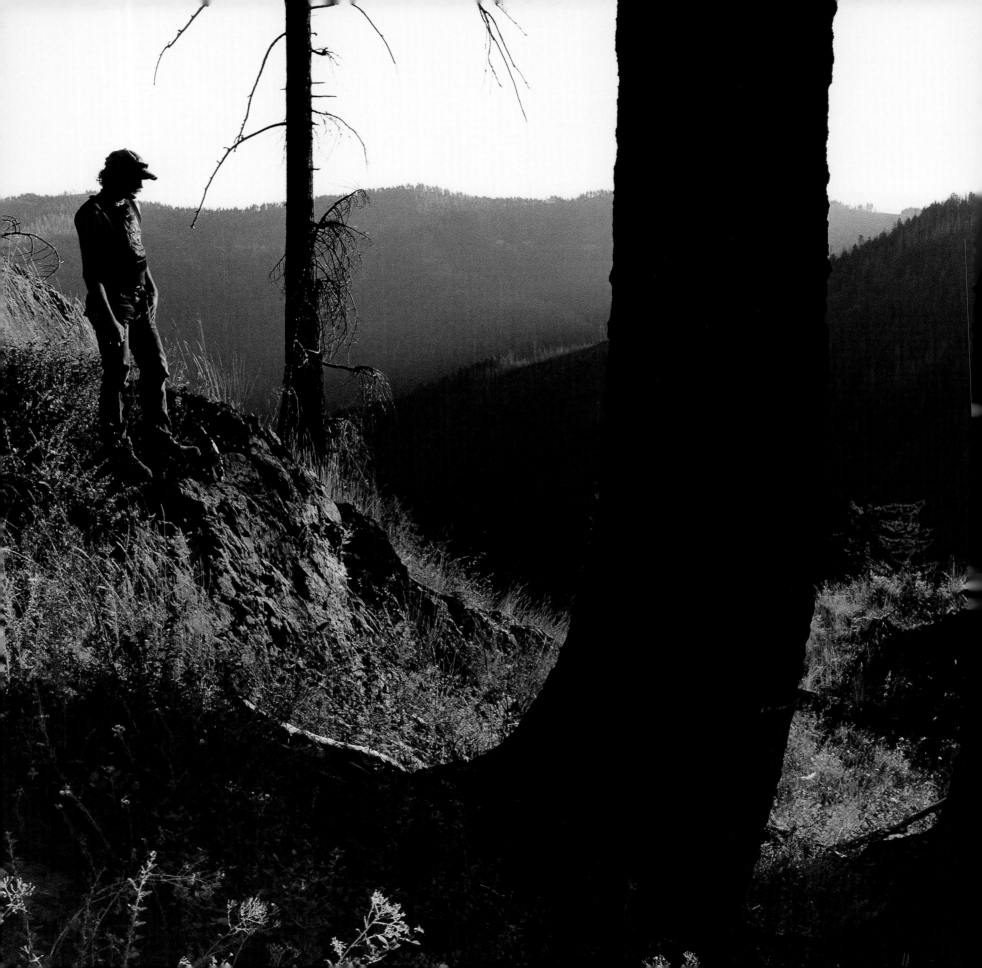

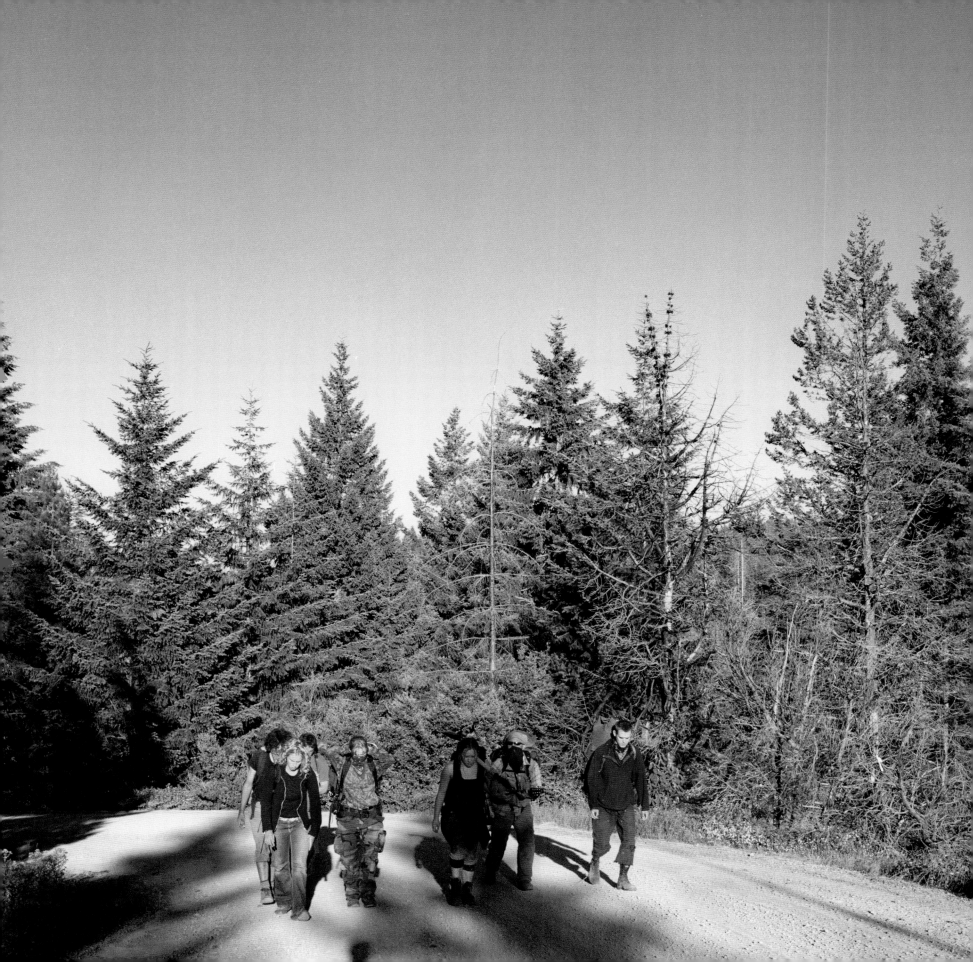

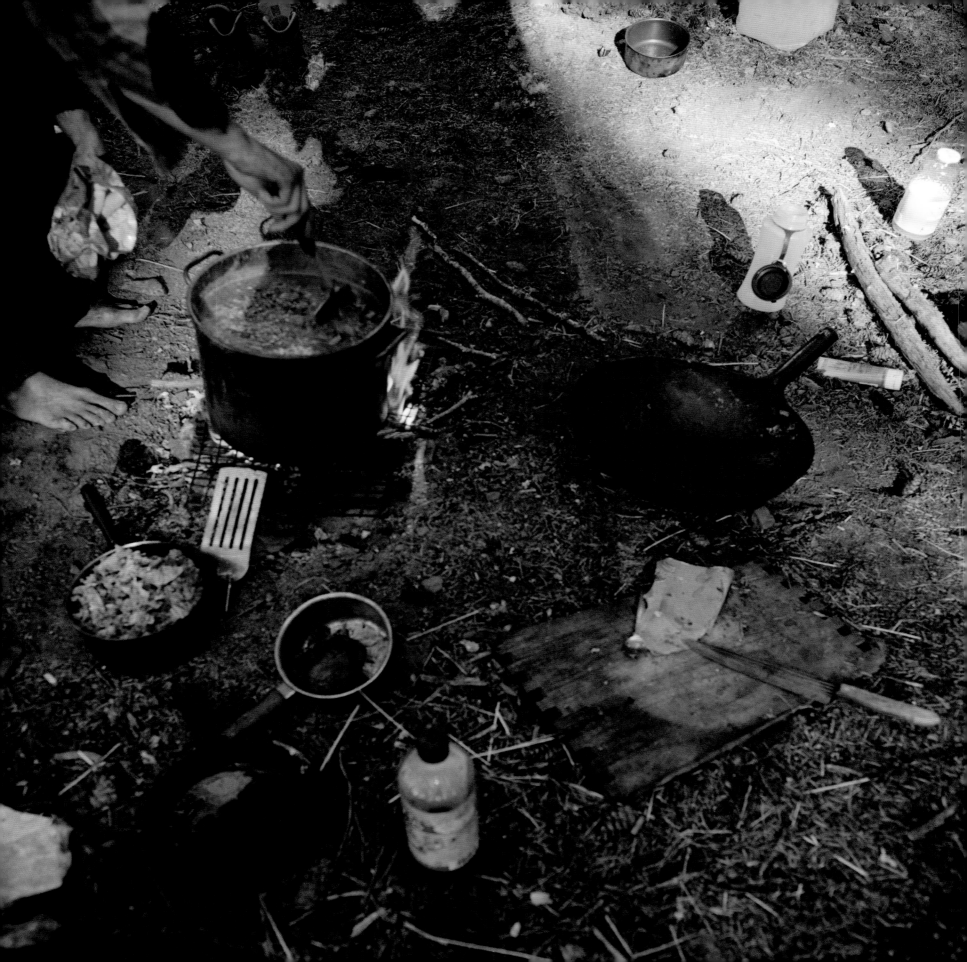

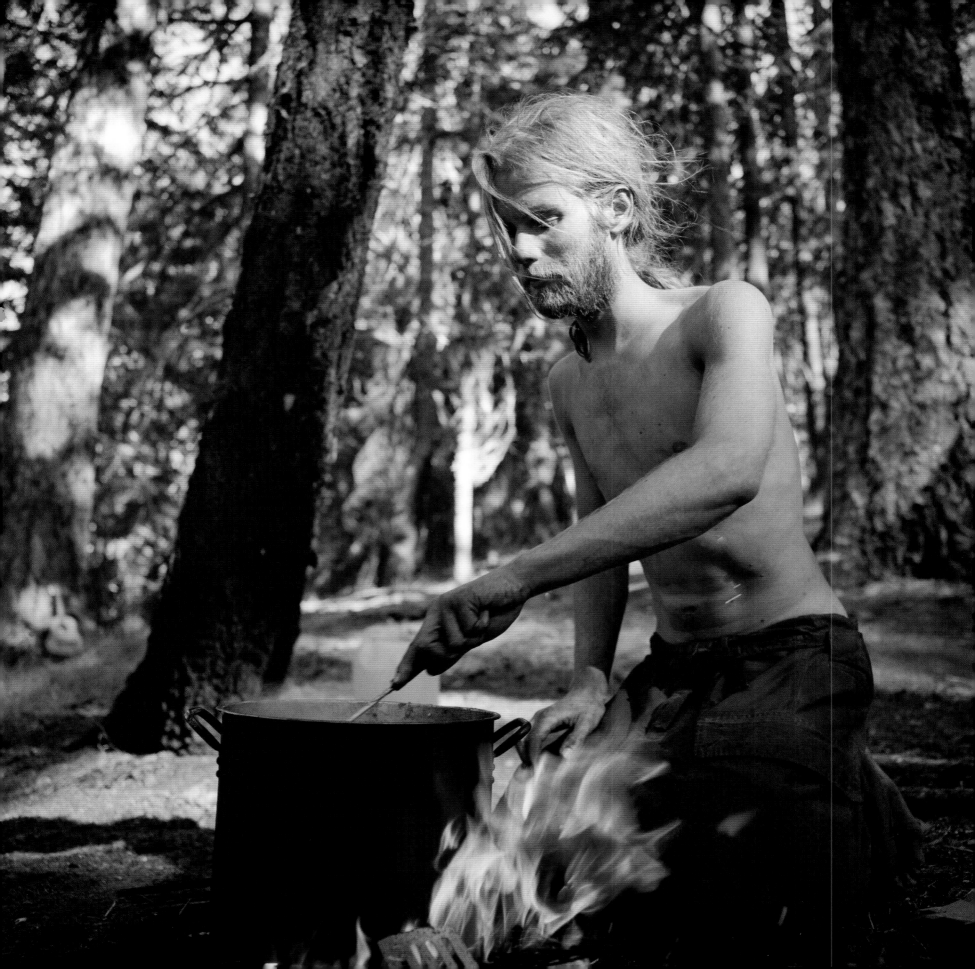

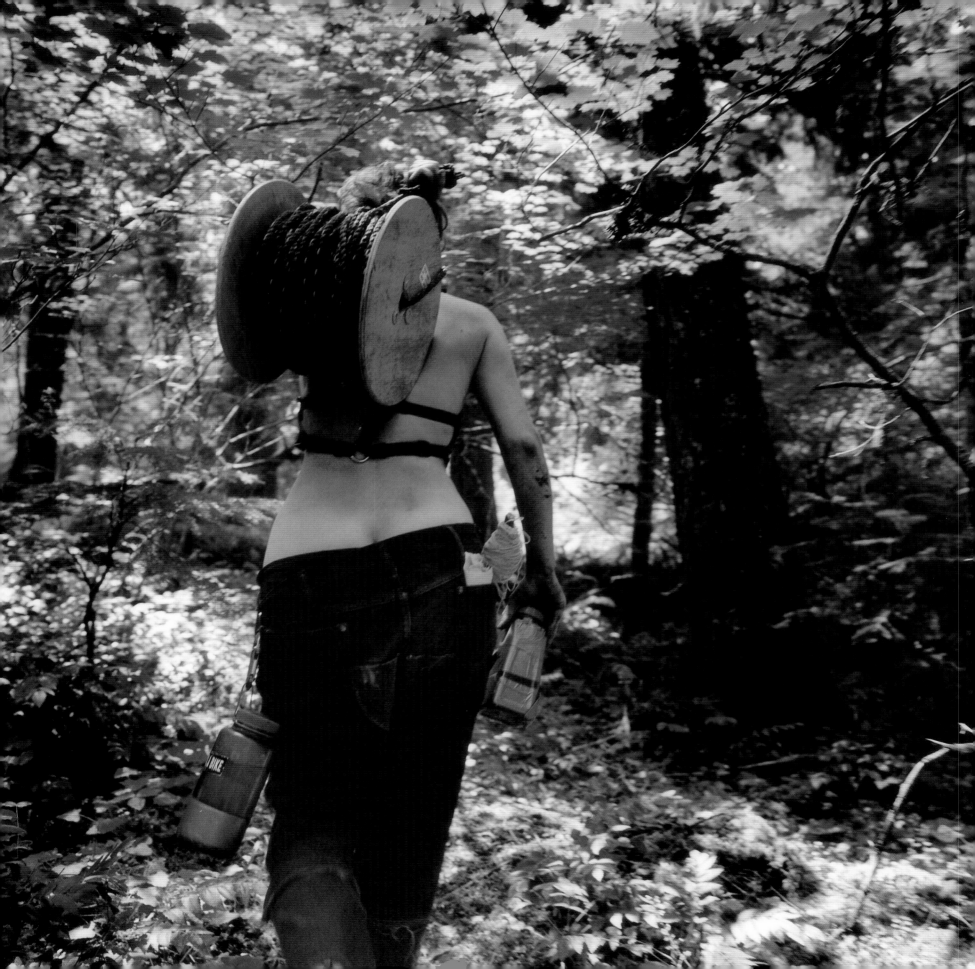

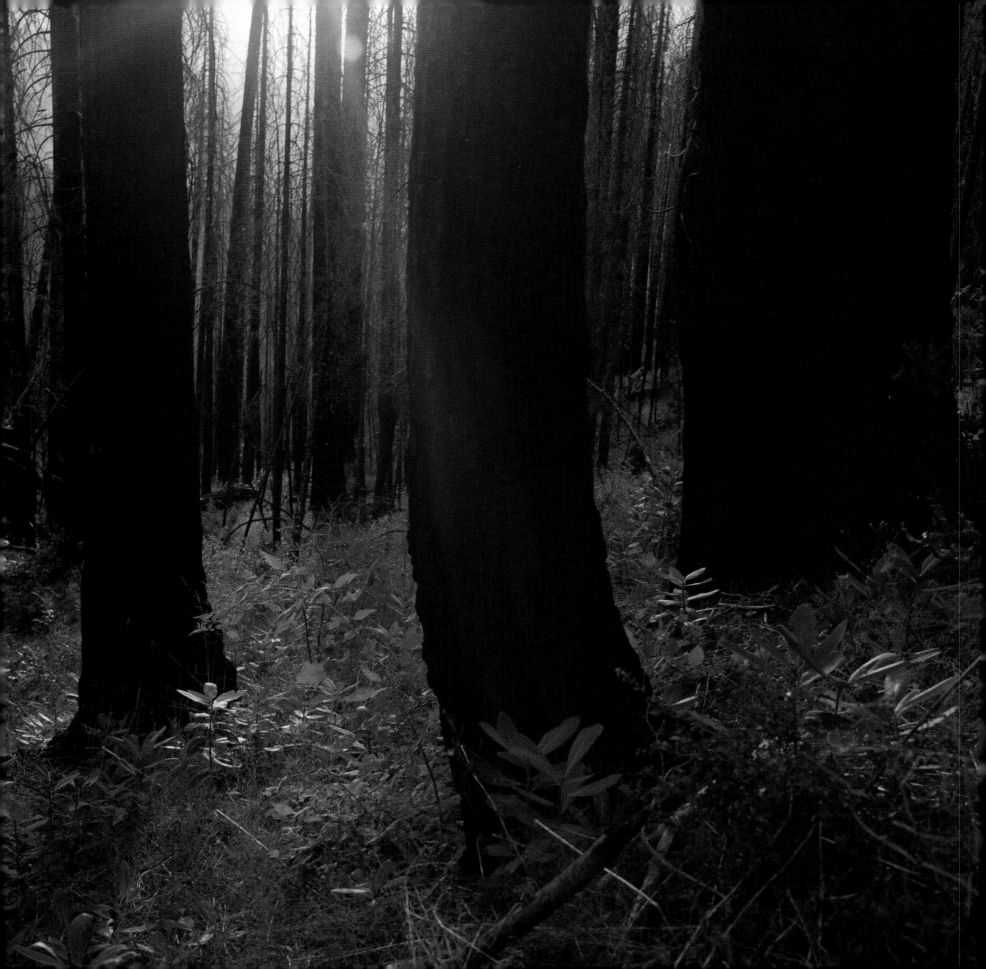

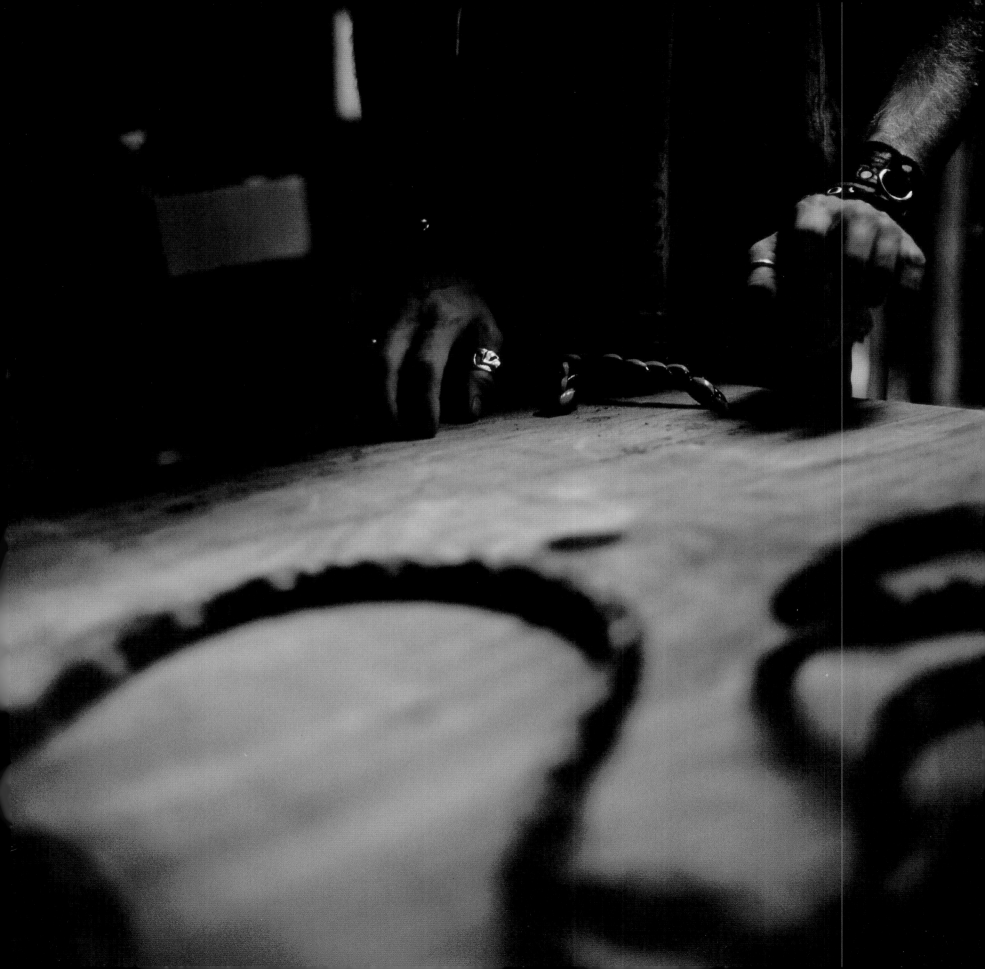

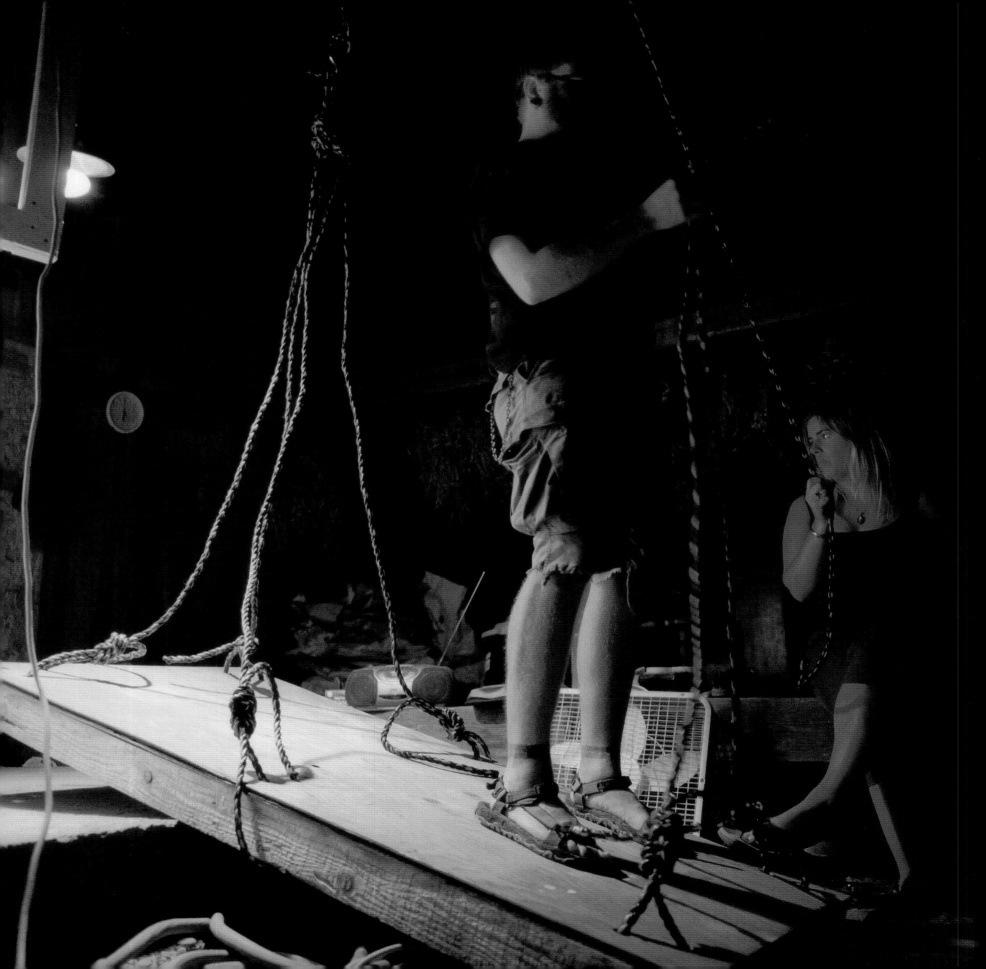

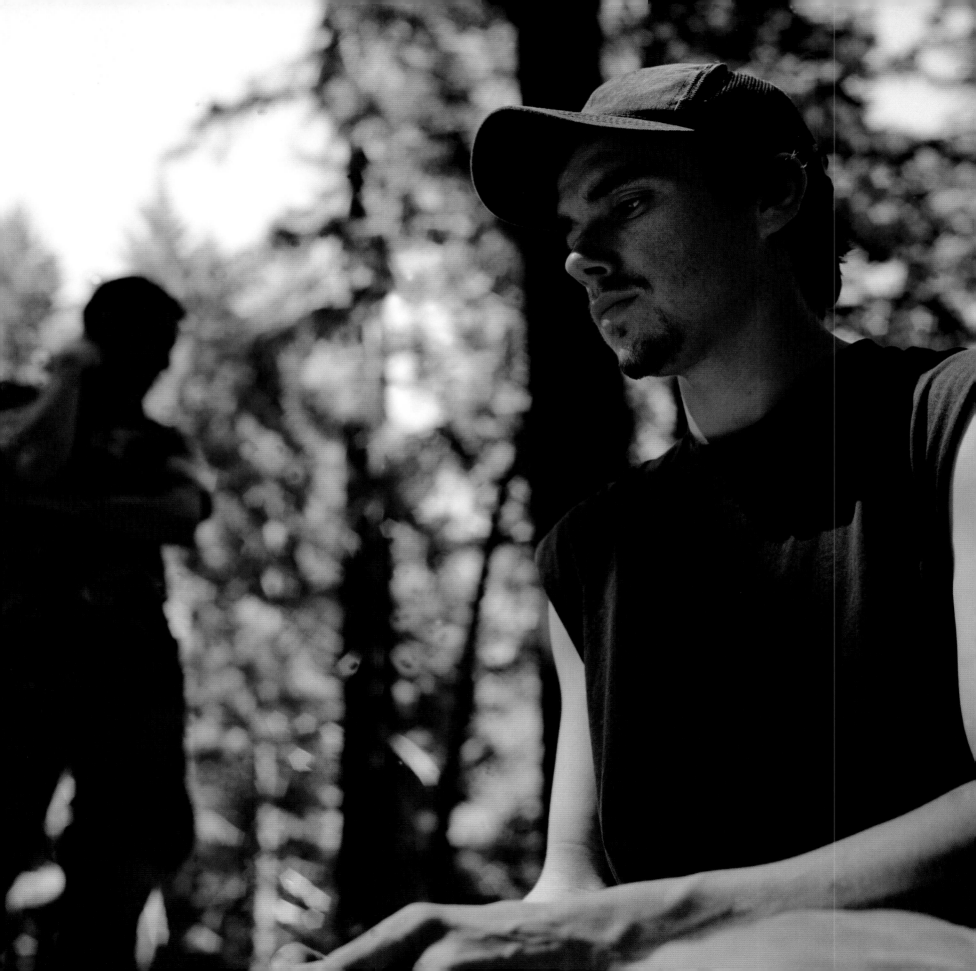

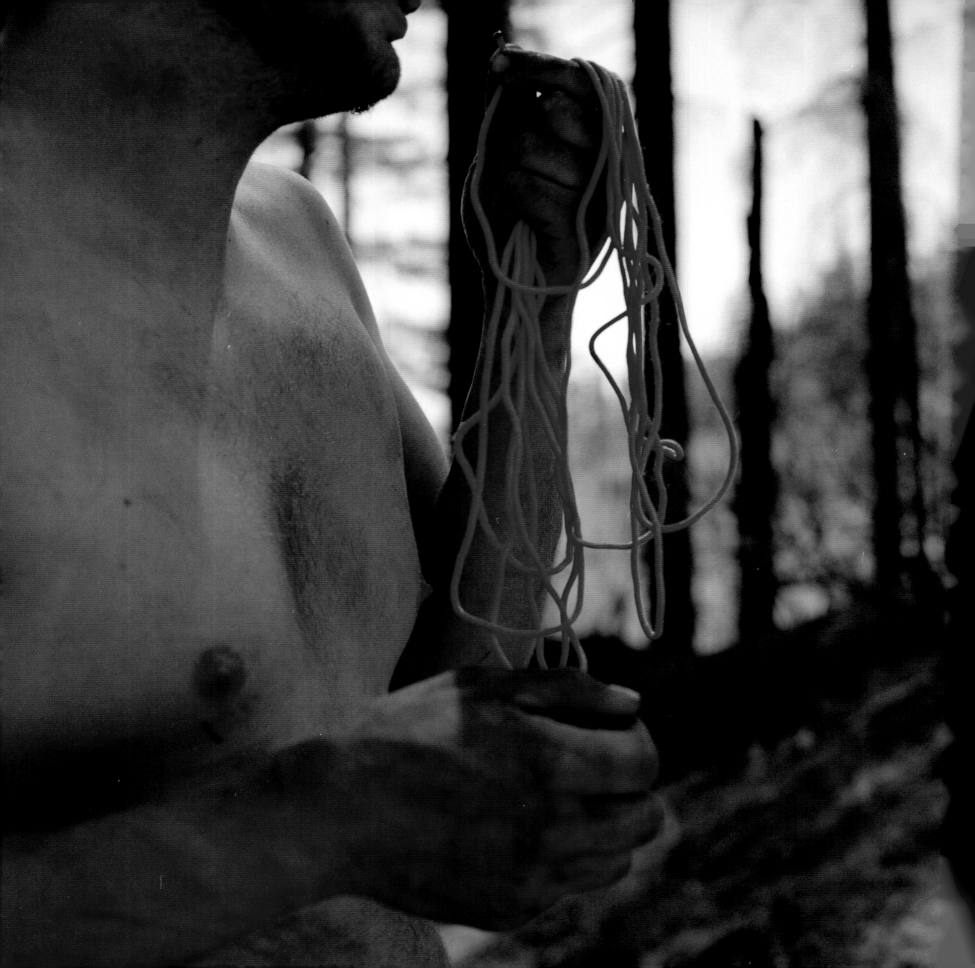

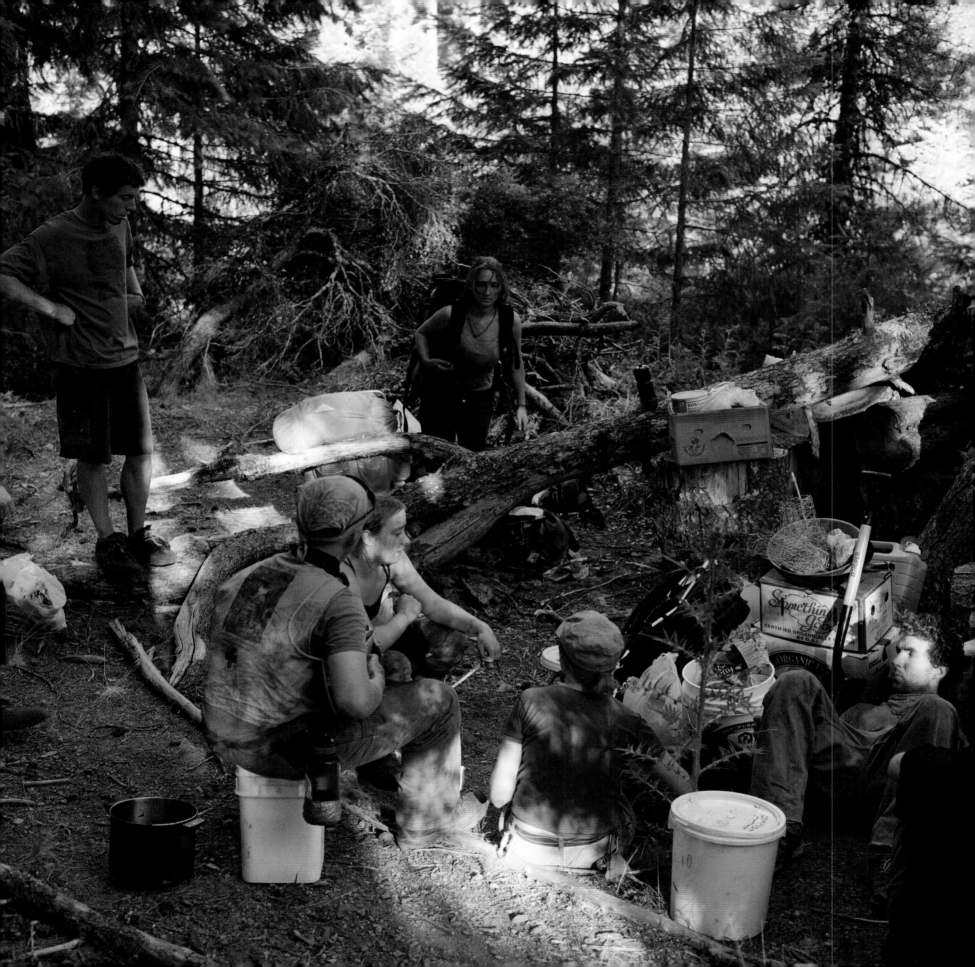

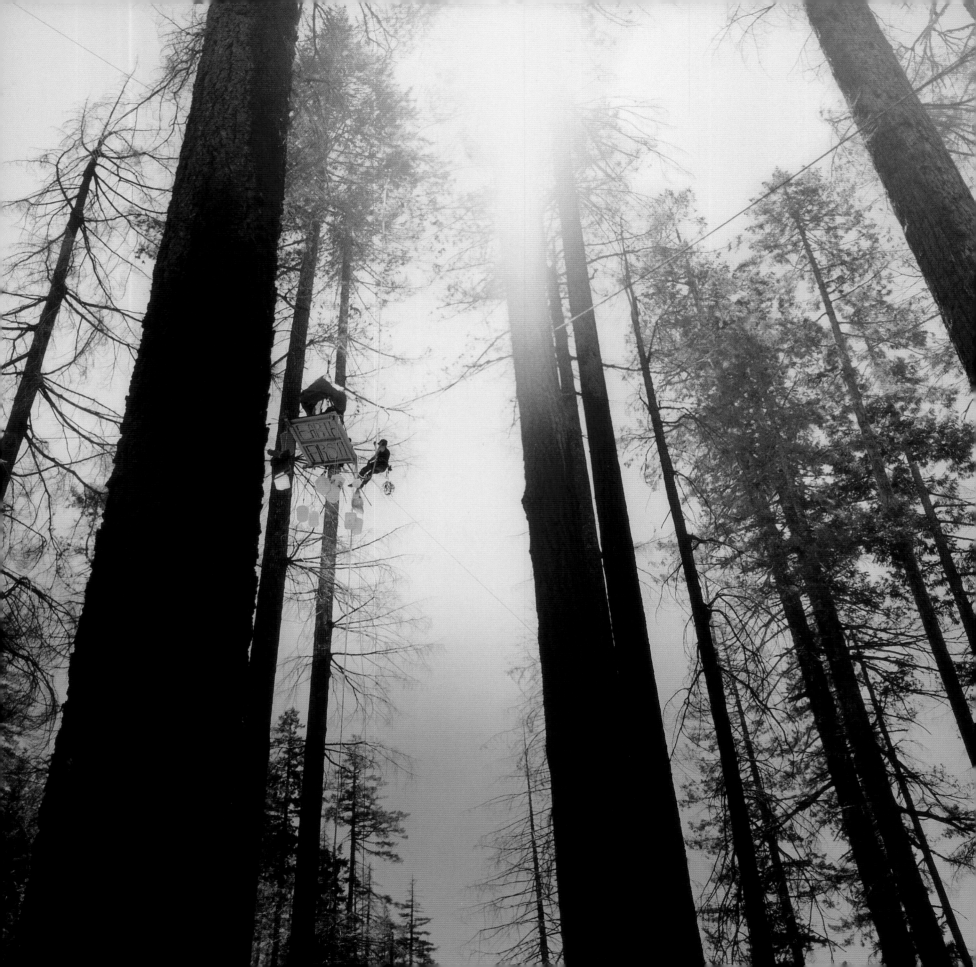

ROAD GHOST

At seventeen, the only thing I felt sure about was that we were saving the world and I believed it with all my heart. This was before the raid on our forest campaign; before Horehound fell and died in the place we named Sunset Grove (an occupied tree-sit village for over five years), before Tre Arrow climbed up and lived for eleven days and nights, fifty feet high, on a three-foot ledge that rimmed the Forest Service building in downtown Portland, Oregon. All of these amazing untold and relentless long hours of work occurred before we saved Eagle Creek.

We had knitted our intimate and devoted forest defense team with such tight stitches, with such fervor and passion that I was sure we were bound together for life. I found new kin and more than that, a purpose that struck me more deeply than I can begin to describe. We were saving some of the last of what is most precious in this world. If you haven't had the honor of viewing the majesty and ancient beauty of the last few chunks of intact forests in the Pacific Northwest, I urge you with as much encouragement as I can to do so. Who knows how much longer we will have what little remains now. There is nothing I can write that would even begin to describe its real beauty, the consequence of its loss, and the dire importance of its very existence. The intensity of its absolute becalming grandeur is beyond words. Once there, suddenly you grasp why there is no question about the necessity of keeping this complex ecological network intact.

In the summer of 1998, two road blockade pods were erected on Forest Service logging roads 4615 and 4614, the only access points to the controversial Eagle Creek timber sale in the Mt. Hood National Forest in Oregon. Those two roads served as the focal point of our stand. Our thriving, motley Free State went on uninterfered for so long that we were beginning to feel like our new way of life would never end. We had names for many of the trees out there and I could navigate a swath of the area at night with little moon and no flashlight, traveling just on the memory of the roots and rocks in my path. To me, our camp was perfect, but it didn't look like much to the outsider. Most of the stuff we had out there was originally built with a different purpose than its current employment, and everything was patched up a few times over, while lots of things were outright invented and homemade. There was a large patch-work quilt of layers of tarps above our heads that we kept erecting in futile attempts to keep out the ever-persistent Pacific Northwest rains. However, there was nothing we could do to stay dry when a small stream opened itself up from the heavy rains one day and swam through camp and right into our fire circle. We had twenty-four hour security so upon entering camp you were always welcomed. Almost everything we had at the camp was communal and for some reason, when folks came out to visit, they were inclined to leave something they valued or found special, so an impromptu altar began around the gate. At night around the fire, you could always find fervent discussion about some new disaster, the ridiculous and grandiose brainstorming of the next bigger and better blockade, war stories from old timers of past camps, and actions or far-fetched stories about the super freddies (believed by some to be ex-military employed by the Forest Service to spy on forest defenders). We had workshops and skill shares. The road blockades went on in the summers and in the winter we would have to snowshoe in supplies and goodies to the tree-sit village. In the summer we would bike the seven-mile difference from camp to camp and climb over a hundred feet through misty, swaying treetops and into the extravagant. The platform walls were covered with pictures, quotes, drawings, and findings from the woods, like deer antlers and climbing gear. Traverses (horizontal nylon climbing lines that go from tree to tree) stretched out so that you could glide in a network of webs without ever setting foot on the ground. There were nights someone would come out that actually knew how to play the guitar and we would sing until morning, beating on pans and sticks. If sight could sing, then at night we had a chorus of such grandeur and intensity you did what you could to never have to sleep. Forest defenders over the years have written countless songs about their life-changing experiences and we had a theme song for every part of our day. How do I even begin to encapsulate and describe an experience so full, so rich and formative?

This was our home, and we were defending it with our lives. We ate, worked, and lived together, committed to spending the best and worst with one another. We sat through hours and hours of tedious meetings, and stayed up all night pulling security shifts in pairs of two, making occasional jokes on the radios as boredom set in those long nights. We sang songs, shared our life stories, and went to jail together. We snuck into closed areas under twenty-four-hour security, creating diversions and raising a tree-sit thirty feet from a distracted Forest Service law enforcement officer.

We built two pods each out of four poles, some netting, a cozy sleeping bag, and a foam ground pad, as well as a tarp that wrapped the whole thing up from the constant rains like some ridiculously large Hershey's kiss. These two pods were what we counted on to blockade the roads. Everything had to be lashed down and food was stored in old five-gallon buckets that hung from the side. We learned the hard way that the pod had to be tied on one corner to keep the winds from spinning it in circles, giving occupants motion sickness.

The village was Sunset Grove and on the upper road stood a pod we called Road Ghost, and on the lower, a structure known as Low Rider, which was the one that I lived in. They blocked the only two entrances into the area. Our strength came from our collective passion, a force so fierce it drove us on into the backwoods mile after endless mile and night after sleepless night. I truly felt that there wasn't anything I wouldn't do to save this place, a feeling all of us shared. You can't turn your back on the Garden of Eden, can you? Little did I know how soon all this was about to change.

At four o'clock in the morning on July 7, 2000, I was suddenly blinded with the headlight beams from a dozen or so Forest Service law enforcement vehicles. All around there was yelling, some coming from the tree-sit right above me and some from Low Rider which sat just above where I was standing. "They're here! They're raiding! Everybody get up! Wake up!" Knowing the police would soon force everyone who was still on the ground out of the area, I free climbed up into the tree sit we called Guardian, positioned next to the pod for support. I had a moment with Artimus, the determined, strong, and inspiring woman who had been occupying the support tree-sit. We both knew that this was it, the very situation we both feared and were waiting for. I yelled across to Low Rider to reassure the occupant that we were all okay, but there was no reply. The police interrupted on bullhorns, "We have issued a closure. It is now illegal to be here. Anyone that is still here in ten minutes will be arrested. You must all vacate the area immediately or we will take you to jail." Again I tried shouting to the person in the Low Rider pod. He was new, having just arrived the day before, and had said that he didn't really want to be in this position. The police said they wouldn't arrest anyone as long as they came down out of the platforms now. Artimus and I shared a long hug and exchanged a few reassuring words before I left the platform. I free-climbed further up the tree and traversed thirty-five of the seventy feet of climb line that supported the pod I safely clambered down into. The pod was built with five small support lines anchored at the gate sixty feet below us and reaching up to a horizontal traverse line, through a steel ring and down to the platform of the pod which was a six-foot-wide and ten-foot-long net that served as our bed and home. The new forest defender put on a harness and together we stripped the Low Rider of all its unnecessary gear to protect it from getting confiscated, should the worst happen and the blockade be taken down. Our organization worked with such scant resources that we were very conscious not to lose or waste what might remain useful. In less than ten minutes, the area was cleared where moments before had lain the heads of my gently sleeping friends. We were invaded and our haven was now teeming with police tearing it apart. While things were being hacked open with knives, altars were kicked around, containers of food were knocked over, and they successfully destroyed it all. Huge men in camouflage appeared from out of the woods saying that we had been watched and under surveillance for days. During all this, the Forest Service retied Low Rider's support lines one by one from the side of the gate. Touching any of them put me at risk as they were tying these already thin lines to a rusty metal edge, causing the pod to shake with each rope transfer. This effectively

made it so they could open the gate under us and render our blockade useless. As day broke brilliantly after a soft sunrise, Artimus and I shouted our resounding resolve to each other and we sang songs and joked to pass that unnerving time. Hours and hours of waiting brought what we feared most: the moan of a cherry picker as it made its laborious way up road 4615 to Road Ghost where we knew our friend Spiral awaited. We heard nothing more for too long of a time; the police elected to exclude us from having any information, which only lengthened the time and made it even more unbearable.

Road Ghost was tied like Low Rider, so if the lines were compromised or the gate opened, the pod would fall. Each one had a noose attached and built so that any alteration in the height would hang the person in the pod. A cherry picker at its almost-full reach could make it up to the height of the pods, about sixty feet up. The police came into view with a cocky bravado, sauntering below us and bragging about how they pulled the woman out of Road Ghost by her noose, making her fall head first into the cherry picker bucket. Road Ghost was gone, they said. These words hit me like fists. They continued their verbal onslaught and shouted up at us, trying anything to get us to descend. After a few hours, Artimus and I decided that she should accept one of their offers: she would descend and I would stay. The tree-sit, not actually blocking the road, was just there for support, so we were assured that she would be released without charges. She descended and they quickly reneged on their promise and forcibly carted her away. Artimus would later serve two months in a woman's work-release facility for the stand she took that day.

Hours passed hazily, but still I could hardly believe they were actually here attempting eviction. Eventually they started their approach on Low Rider with the cherry picker. I was frantic. Panic flooded through my veins, pumping pins and needles to each part of my body. I would not let them pass; I would do everything in my power to hold fast, I told myself. Living in the woods as we do, we all carry knives. With a noose around my neck, I yelled down that as long as they advanced I would count down from ten and cut my support lines until there were none left. The machine maintained its steady approach. With my voice shaking more than I care to admit and hoping they would hear me above the engine, I began my first countdown, resulting in the cut of the first of my only five lines. It twanged away forcefully from me to the ground. They continued forward and I did as well. Another ten seconds gone and the second line was cut, leaving me hanging sixty feet up by only three small cords about the width of a shoelace. Still they advanced. Again I counted down and they did nothing, I now had only two lines left. At this point my hands were shaking uncontrollably and my whole body was quaking. I was terrified and needed all the courage I could summon. It was debatable whether or not just two lines of this cord would hold under the strain of the weight of myself and the pod, my home for the last month. I counted down to zero again, stopped myself from thinking about it and cut away the second to last support line. The noose weighed heavy and leaden around my neck and I was scared out of my mind, more scared than I had ever been in my entire life. I tried to focus all of my mind on how one life is insignificant compared to those precious and far too few last native ecosystems that our existence is dependent upon. I closed my eyes and tried not to talk myself out of it. I began my countdown for the last support line. Each second passed like a lifetime. I choked each number out slowly, and terrified. When I reached six I could see flurries of movement. I reached five and people started yelling. I reached four and heard the most intense sound of relief: they had shut down the cherry picker and backed up the bucket containing the three men that stood in it, poised and strained. My eyes welled up with tears and there was, for the first time since the night before, silence.

No one on either side could think of anything to say. I sat there, knife on my lap, and tried to slow my racing, hammering heart. I was safe for the moment and so were the acres and acres of wilderness right behind me. An hour passed and a new person showed up, one I didn't recognize as part of the Forest Service. He was tall, had dark hair, and spoke very slowly and calmly, telling me his name was Ted. He tried a different approach than the one I had yet received, asking me about my family and how they would feel if something did happen here today and I didn't make

it. I responded that it was the Forest Service's choice, all they had to do was cancel the sale. He later told me that he was with the FBI and talked down people who were thinking of committing suicide. He said he wanted to give me a phone and that he wished I would call my family. I dropped a small line to the ground that we used for hauling cargo and raised up the phone. I called my mother, who was watching all this on the news. She was phoning congressmen and the Forest Service, desperately seeking anyone she could think of to try and plead for my safety and ask them to back down. Helicopters roved overhead with video cameras taping news programs. I called Cascadia Forest Alliance and talked with one of the many amazing people who kept the entire campaign going for so long. Ted told me that he was hoping that my mother would try and talk me down. I tossed the phone out of the pod and it crashed on the road below. The questioning from Ted and before that from the Forest Service had been going on for hours now, and I had only slept for two hours the previous night. I also hadn't had anything to eat or drink during this whole time. I could only catch fragments of conversation from on the ground but at one point I heard that they were planning to try and get me down again. We kept a bicycle U-lock in the pod; I grabbed it and climbed up to the top of the pod and put it on over my noose, locking my neck to the traverse and hiding the key where many smuggle drugs. Even if they got close enough, it would be much more difficult to extract me safely.

More hours passed and by this point, the roadblock had been effectively disabled, but it had taken almost all day. With the stresses on my locked neck, I knew I could only stand without food and water for so long. I asked for another phone and called my affinity group. And now that the road blockade had been rendered ineffective and with more media attention received than we had hoped for, my friends said they thought it was time for me to give up this stand and come back to regroup and help figure out our next plan of defense.

The idea of voluntarily leaving our sanctuary was hard to swallow. I slowly disentangled myself, more and more heartbroken with every passing moment. Even though the pod was rendered useless, I couldn't help feeling that I had failed everyone and betrayed my values and integrity. I was leaving this place that meant the world to me and that wasn't an easy thing to justify. I turned and said goodbye to my home, promising myself that we would all be returning soon to do whatever we could to continue our defense of the forest, and stepped into the cherry picker.

Eagle Creek changed my life in countless ways and I am forever grateful. There are many different forest defenders with astounding stories of heroic bravery and strength, inconceivable and innumerable tales of impassioned stands and vehement protest, too many to account for in any book. I consider myself one of the luckier ones; most of our stories don't end so well. Because of the collective and the devoted actions of so many, Eagle Creek still stands in all its glory, and I can still return there. Most of the time, once we are removed from somewhere that's the last we ever see of it.

That day was over seven years ago. I am twenty-four now and I still defend forests. I still continue to take action and do what I can to try and bridge the disconnect that we have created in this society. I chose to stand for Eagle Creek because I believe that, bit by bit, we, as a whole society and not with direct intent, are slowly committing mass suicide. Instead of facing overwhelming problems of climate change, the fuel crisis, or rising ocean levels, we shut off and shut out the known impacts of our actions. Every day, we choose to look away from the ever-impending catastrophe just around the corner. Each day that we don't take action to make the changes we know are necessary is a day of great loss.

We all have things we cherish above all else, things we are willing to risk everything for, whether it be family, religion, political rights, or a grove of ancient trees. The message I work to send is one of awakening and action. I truly believe with all my heart that if people were aware of the precipice we stood on, the brink that we teeter so close to the edge of, we would have no other choice but to bind together together and stand for all those things that are our truths. It is never too late to stand. USNEA

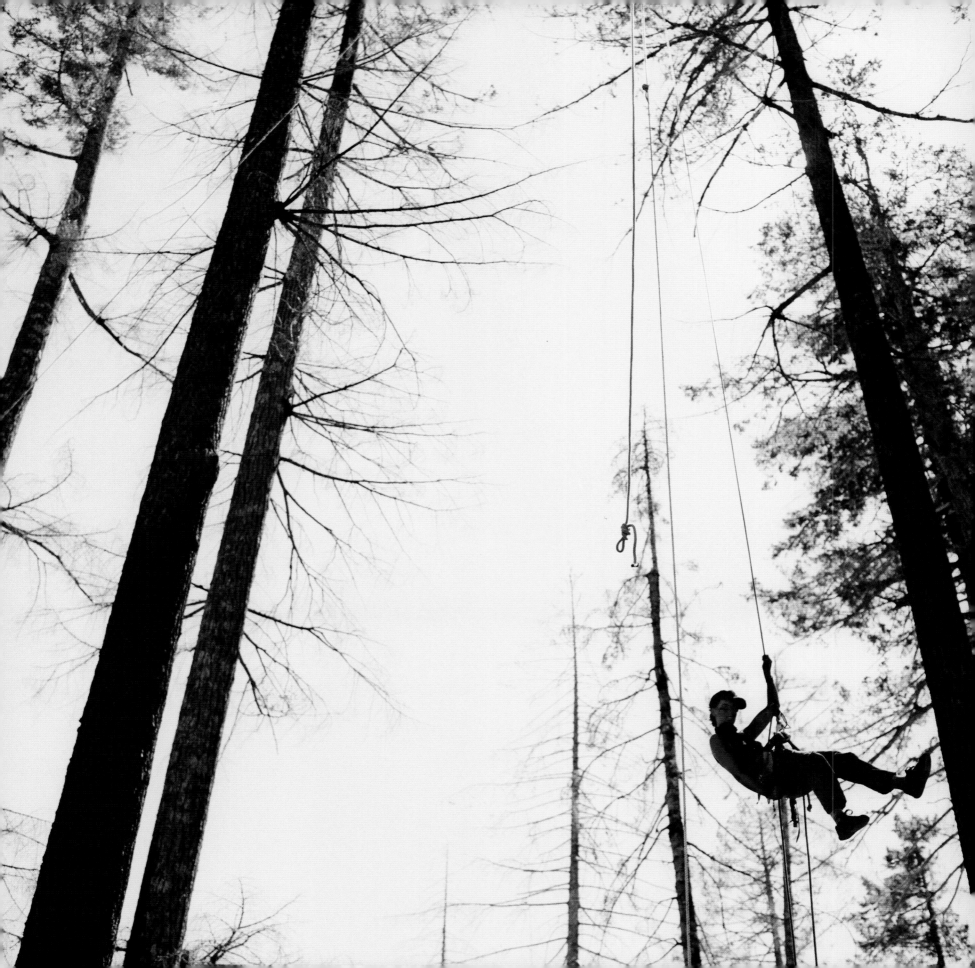

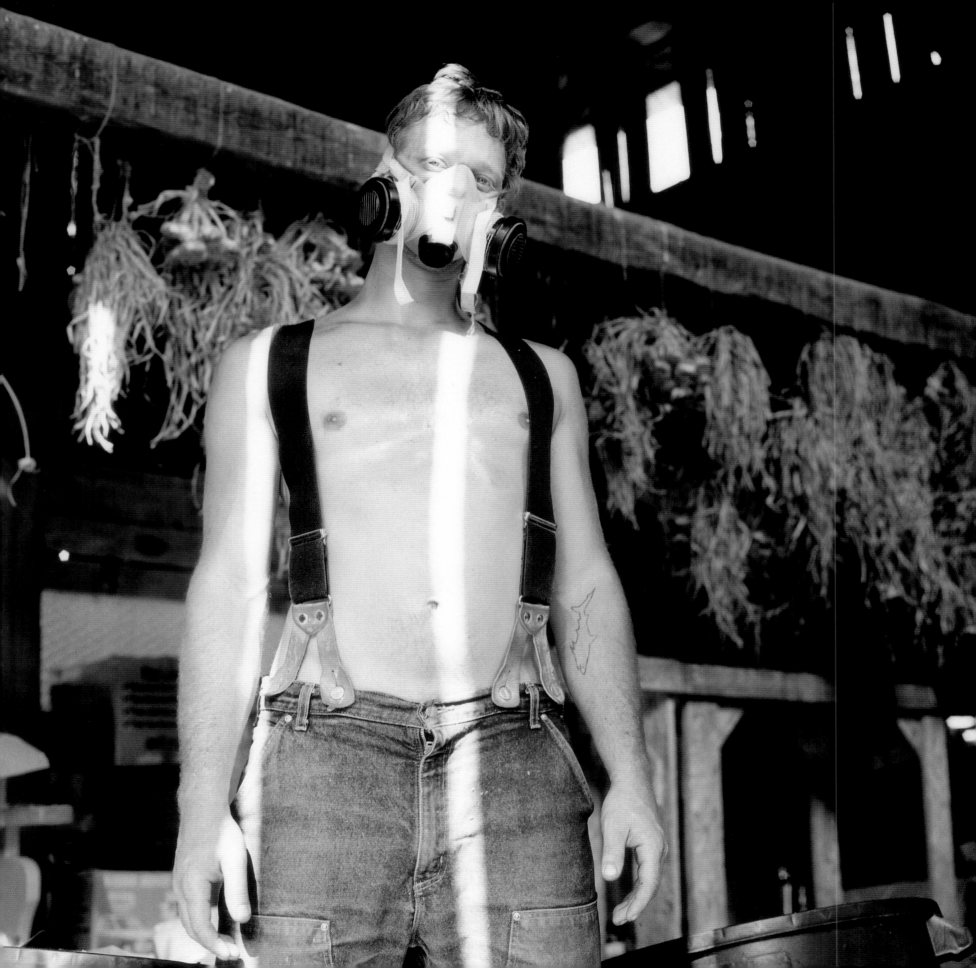

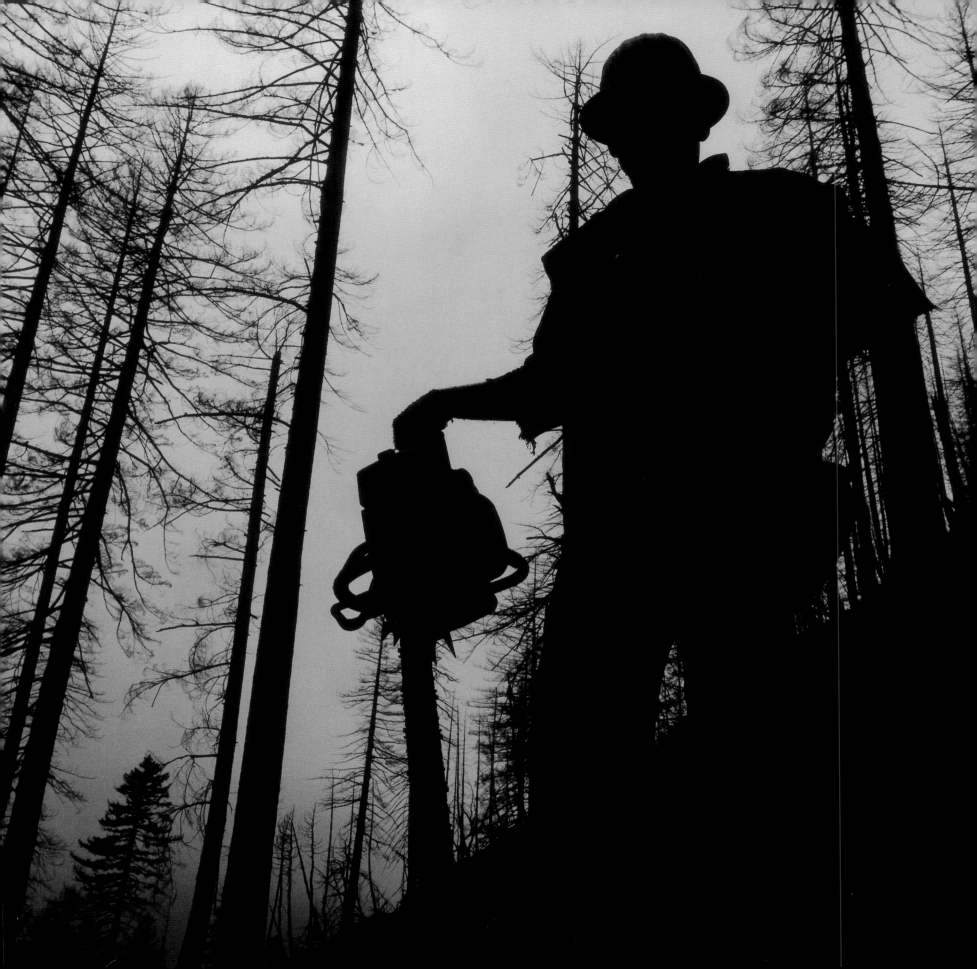

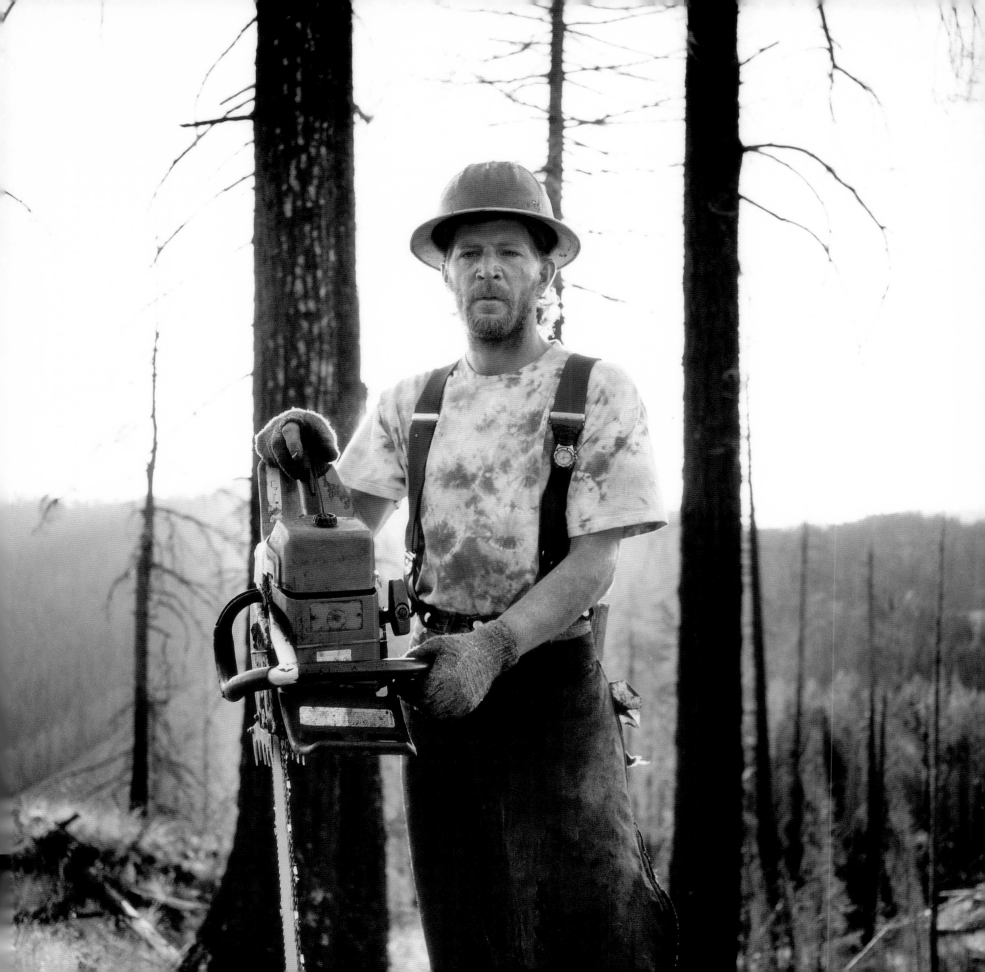

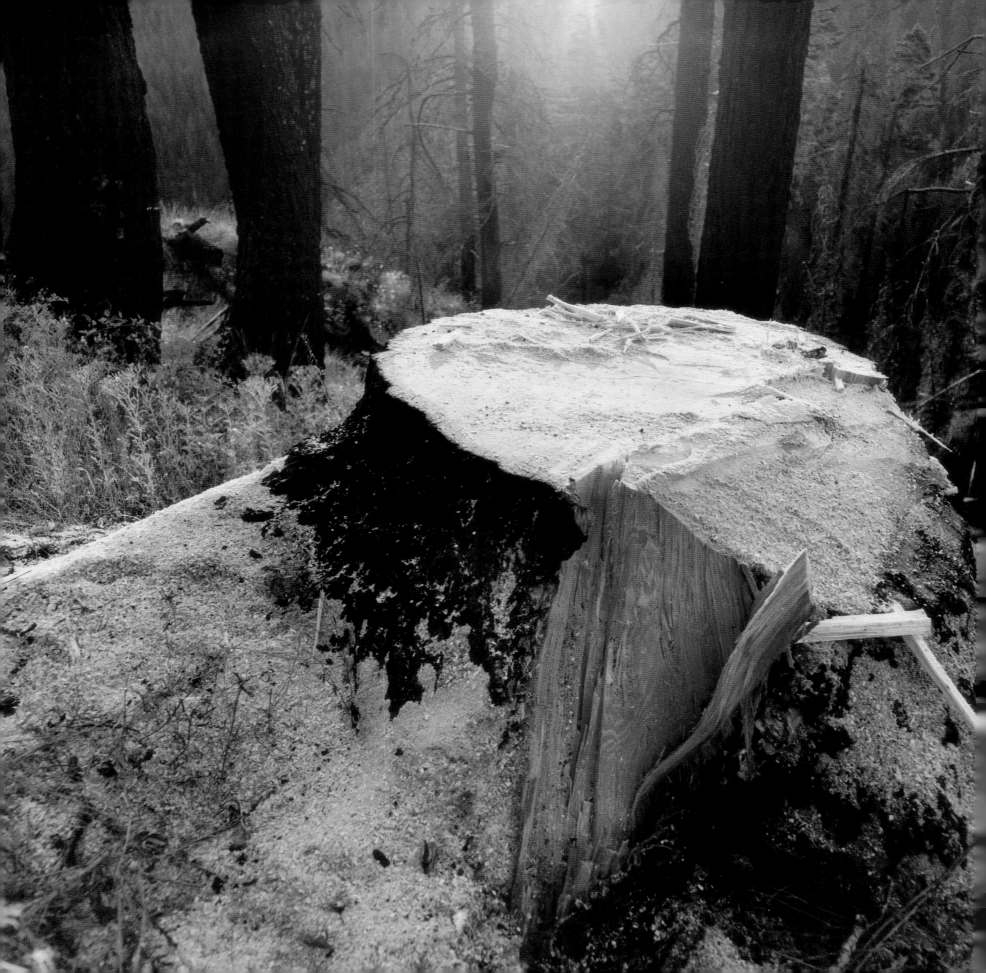

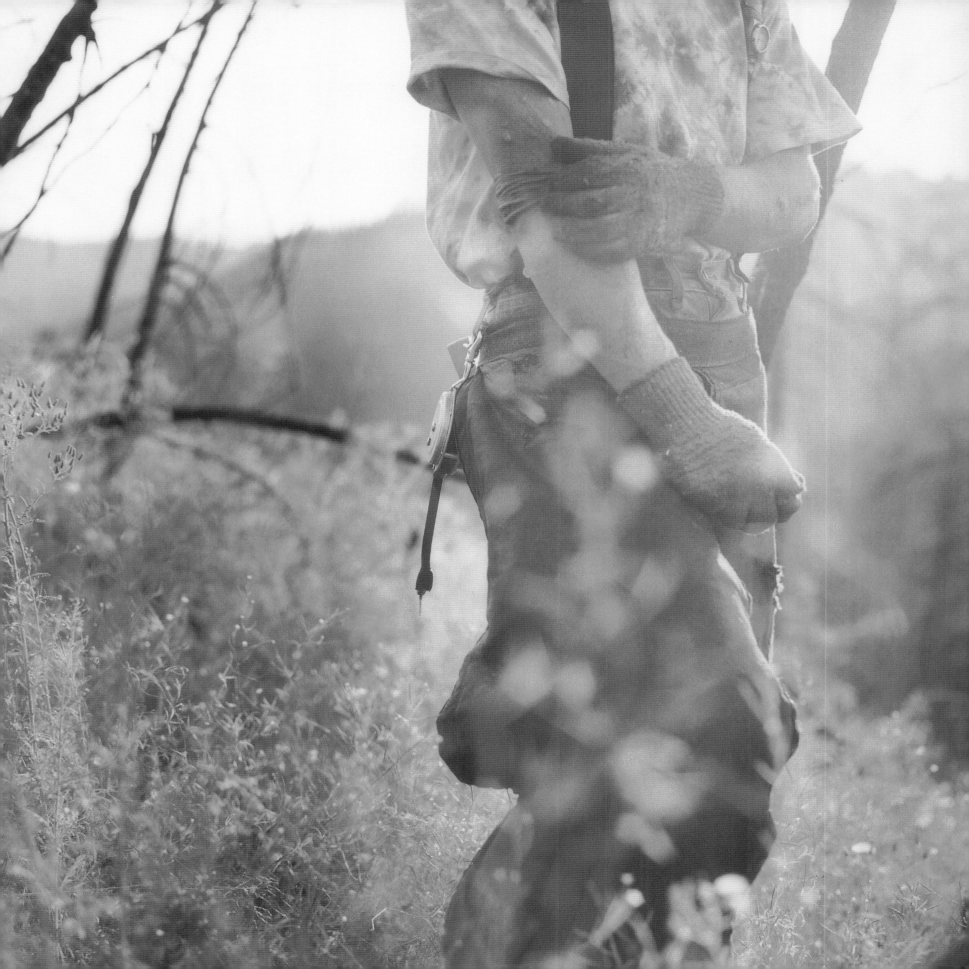

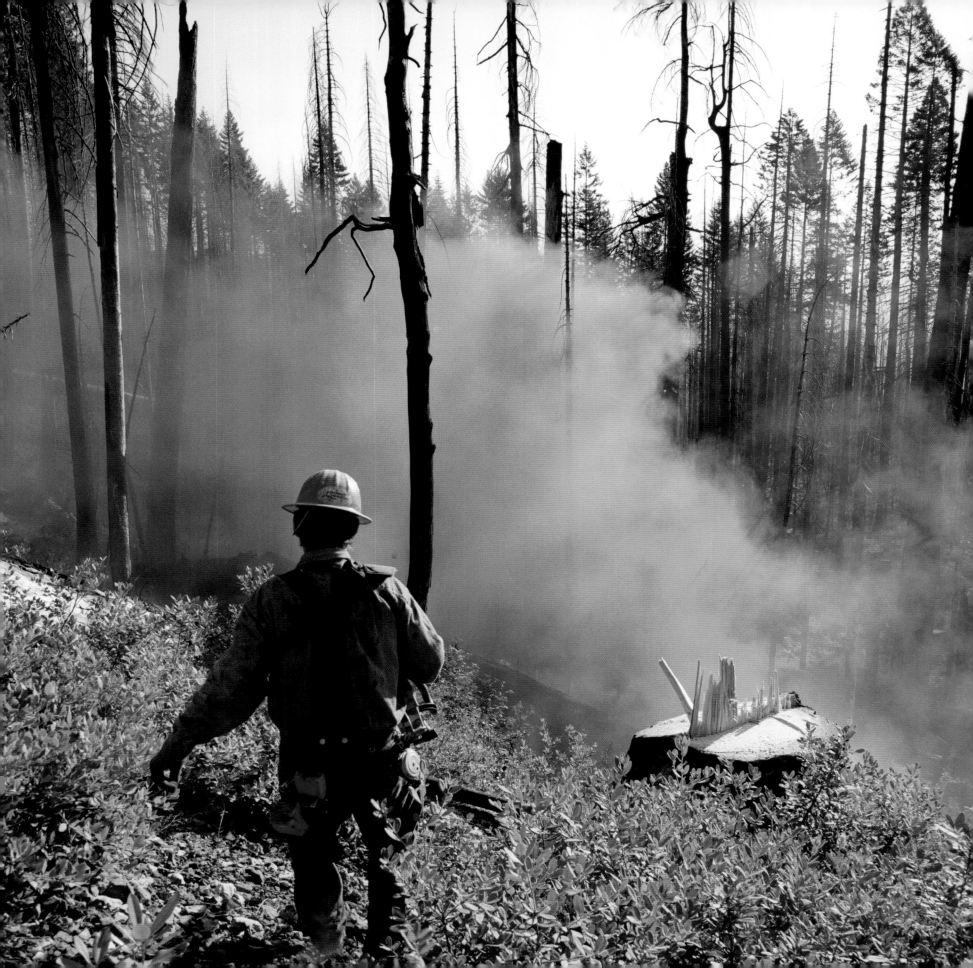

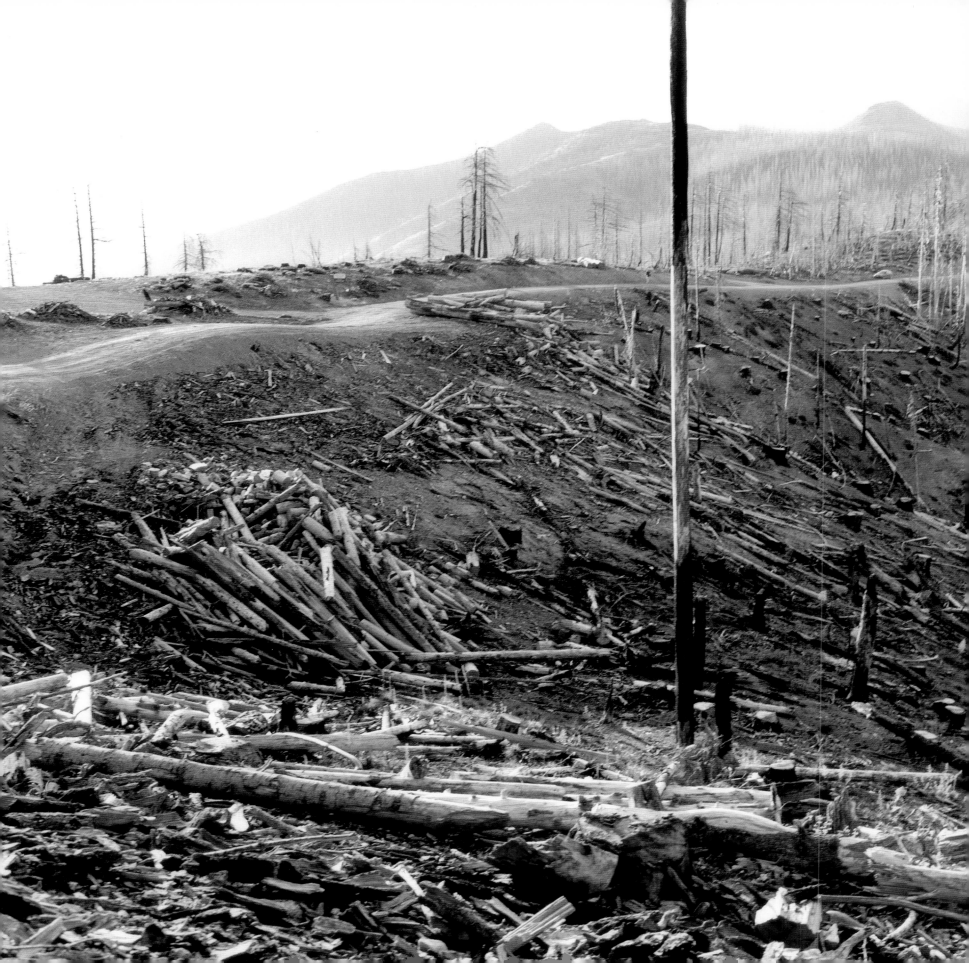

Every morning for the past thirty-five years I have waited at the foot of a forest as the last shred of darkness gives way to the first light of day. I stand in the brush amid the cool air ready to begin my work: I am a timber faller. This is no ordinary job, in fact to me it is not a job at all, but a way of life.

From my experiences as a logger, I have learned more than just the rigors of hard labor. I have learned discipline, serenity, and appreciation for the unfathomable and dynamic world that surrounds us. Working in the woods has instilled in me a humility that has resulted in tremendous benefits in every aspect of my life, and I am grateful for every moment that I spend in these incredible surroundings.

I may only be a single step in the multifaceted process that is logging, but I am the first step. I see, firsthand, the impact of this industry on the environment and on the economy. My perspective is unique and critical, therefore I have always set my work standard to be consummately professional. My main objective has not only been to produce a useful product for society, but also to protect and provide for a better forest. I understand that our natural resources are indispensable, and as a father and grandfather, I want to ensure that they are available and thriving for generations to come.

In this book there may be images and opinions that dispute my point of view; however, I don't worry about that. I know who I am and what I stand for, and the only one I have to answer to is God. At the end of my working day I can look back and see that my efforts have been to produce a healthier forest and to provide for others. Logging is not about destruction, it is about establishing the optimal relationship between us and our beautiful world; it is realizing that when we take, we must also give back. JEFF HAMMERS

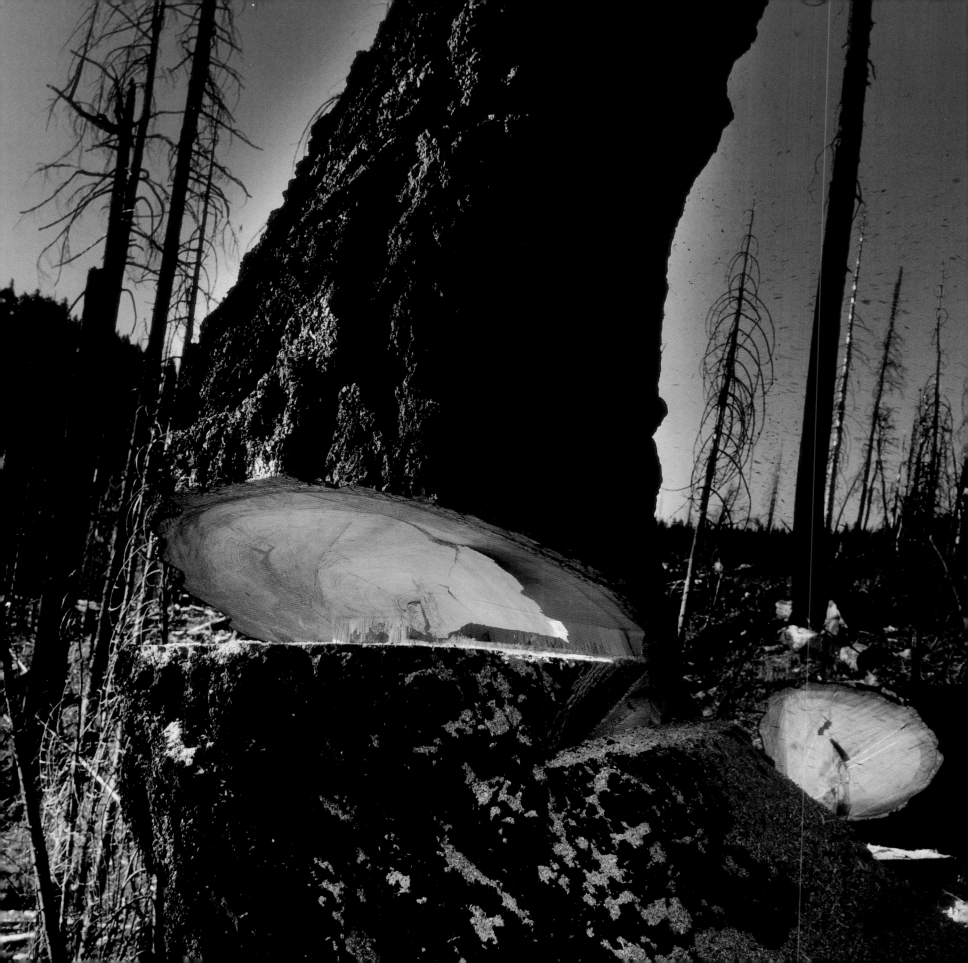

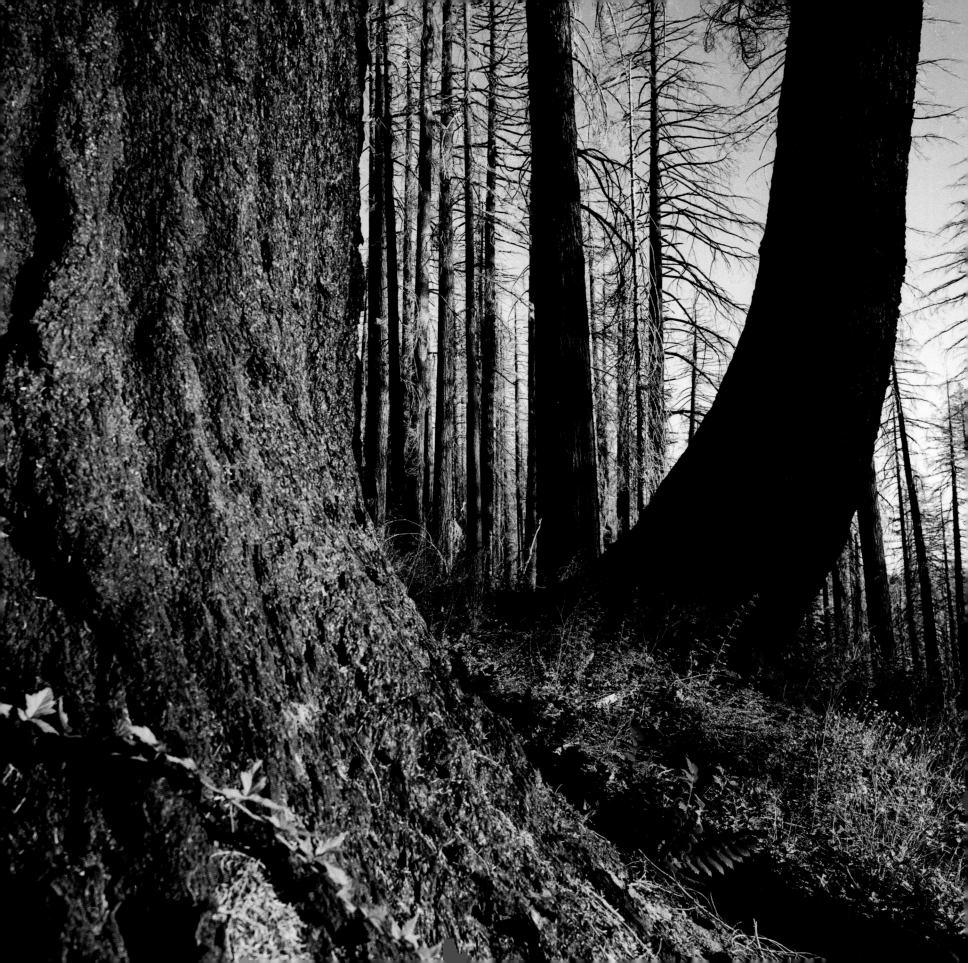

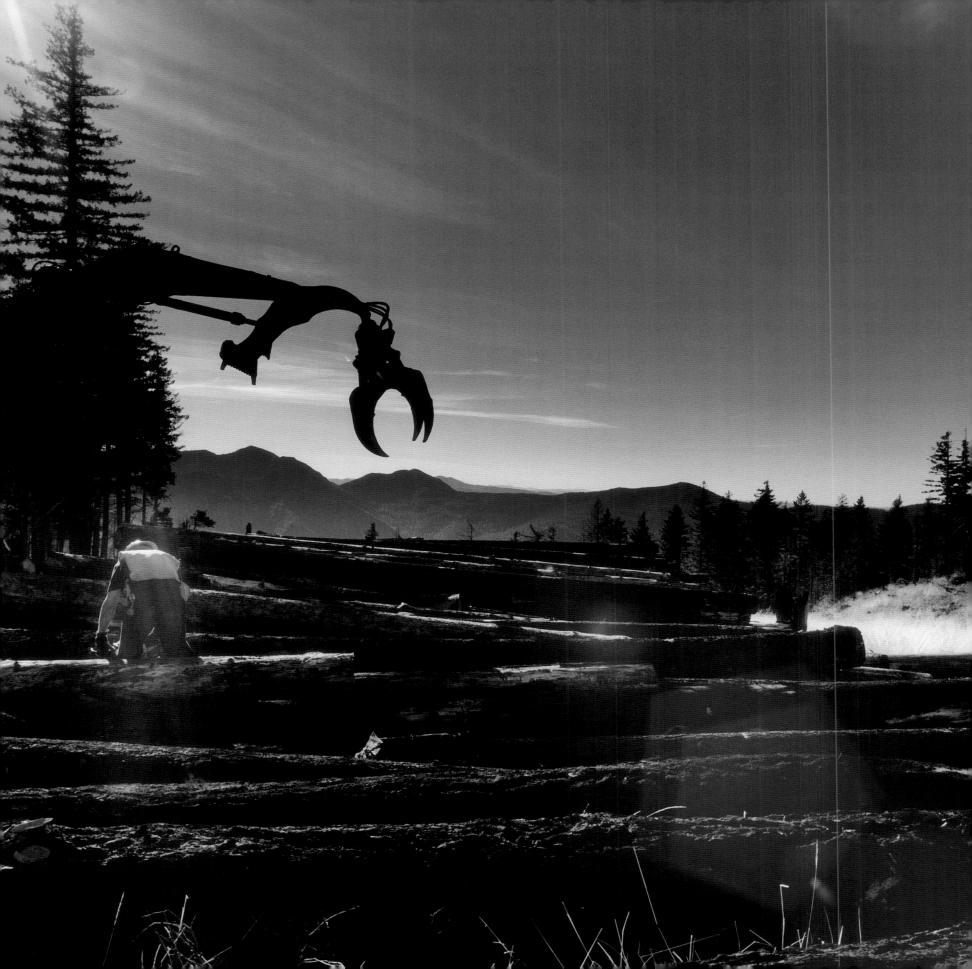

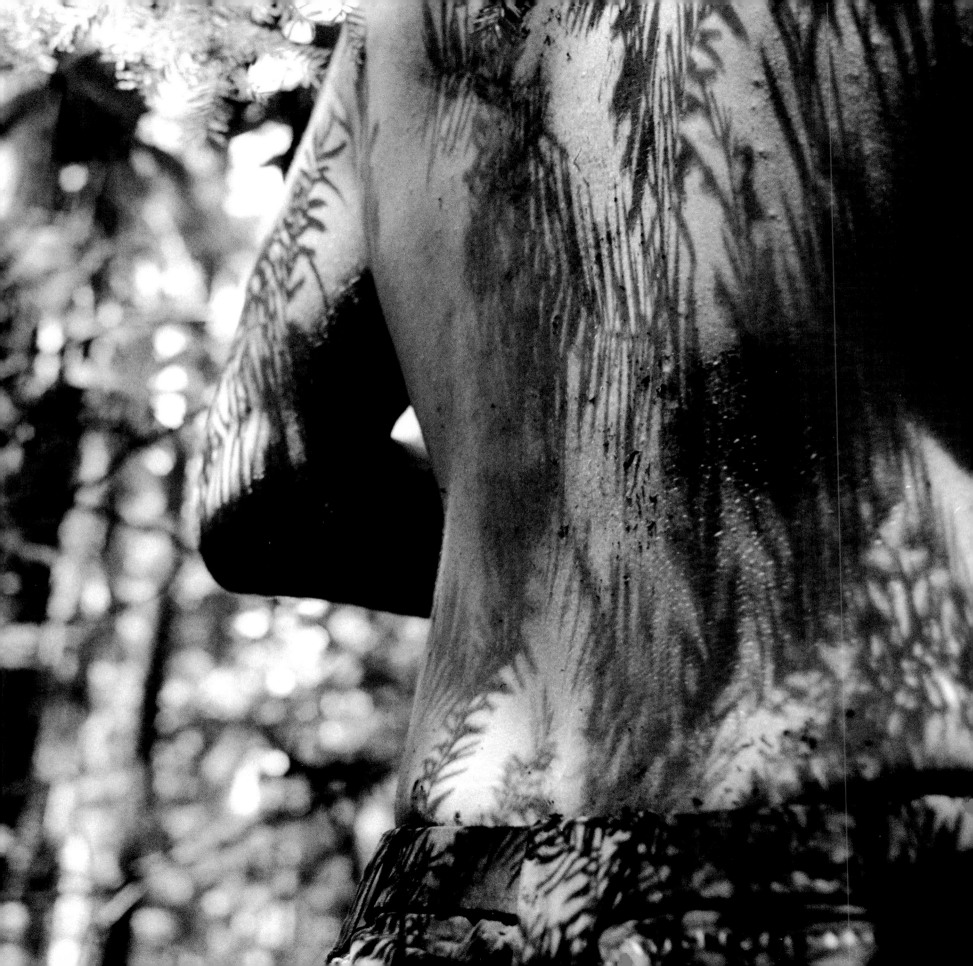

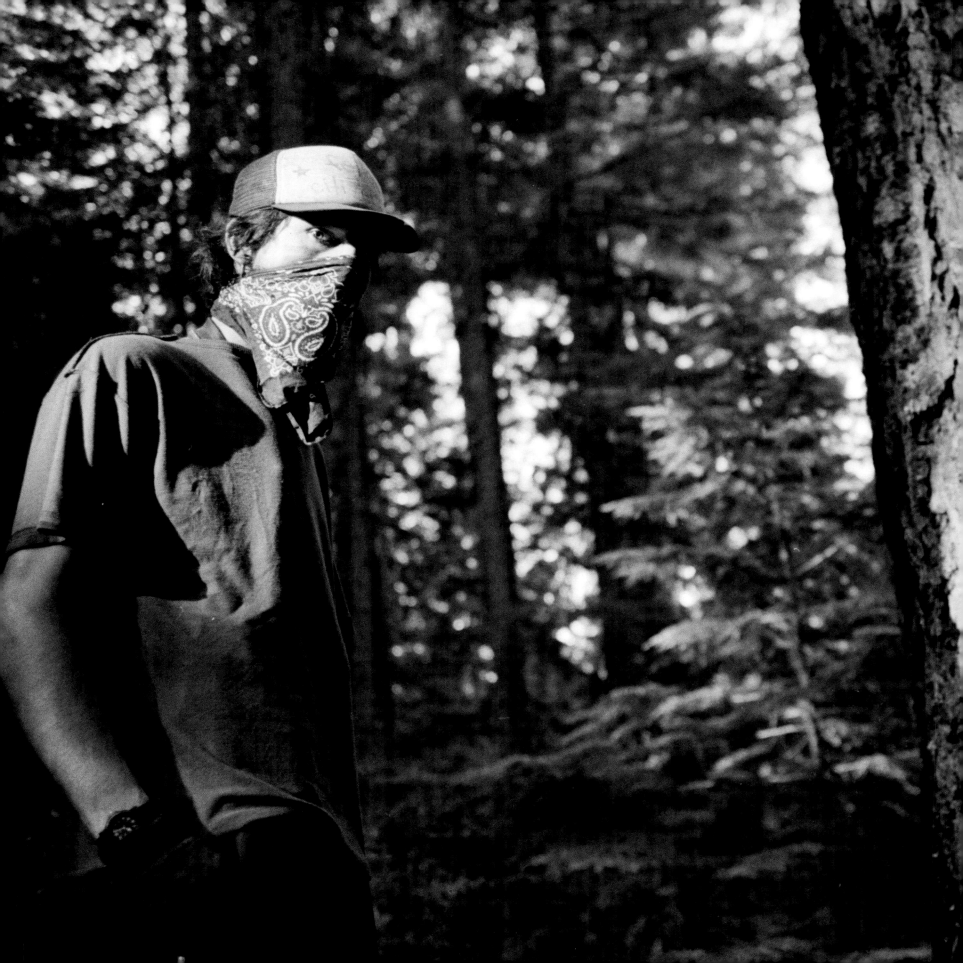

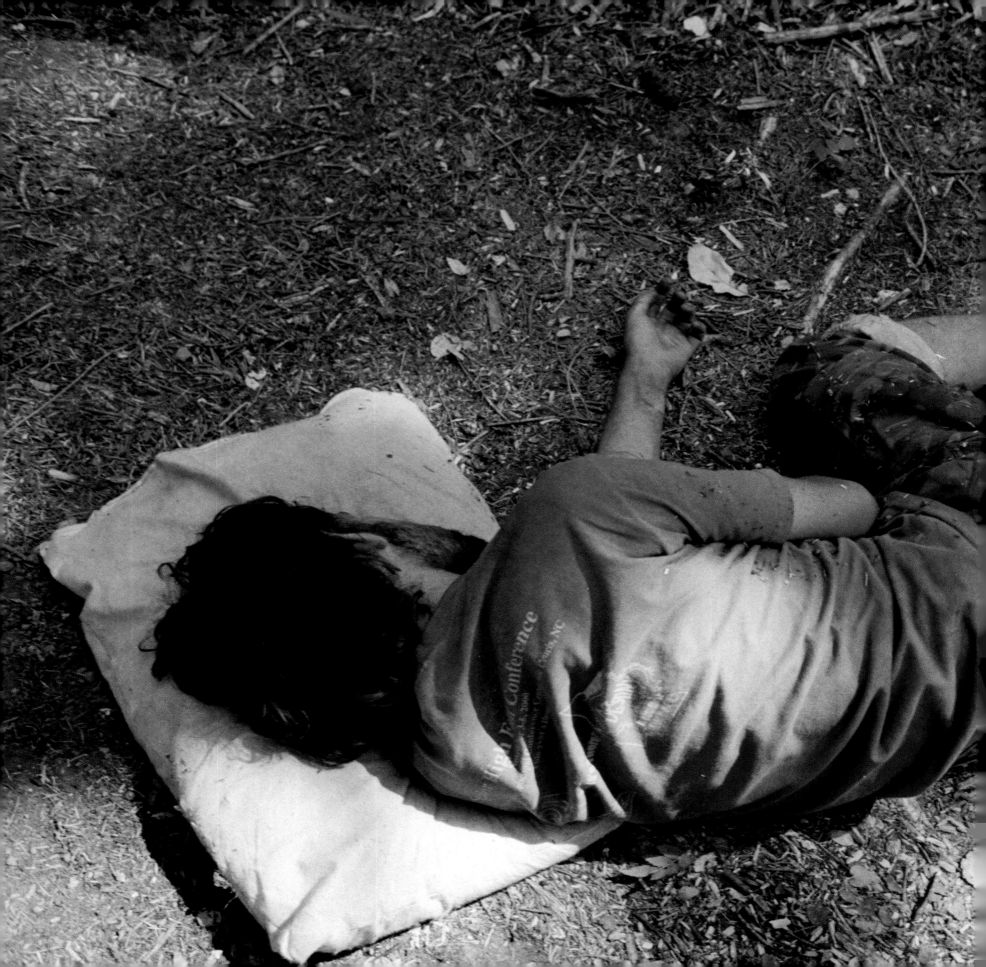

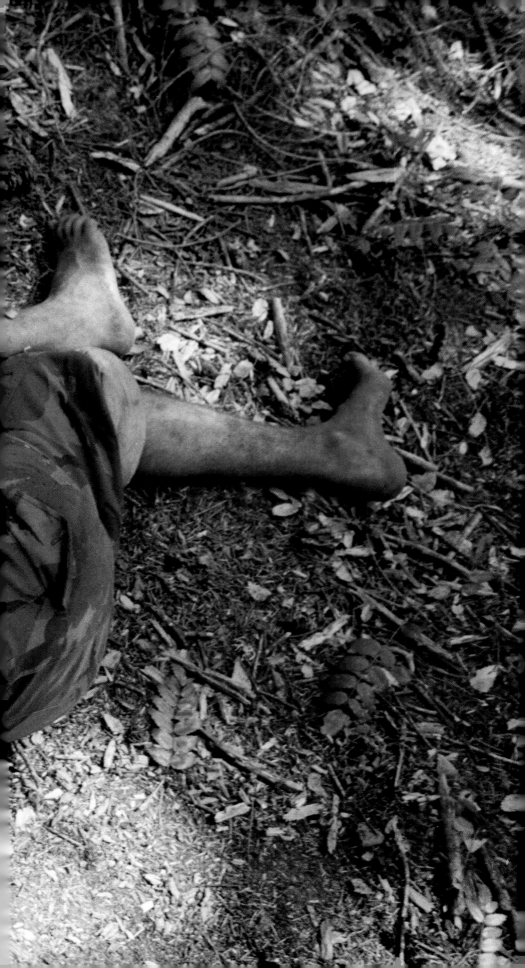

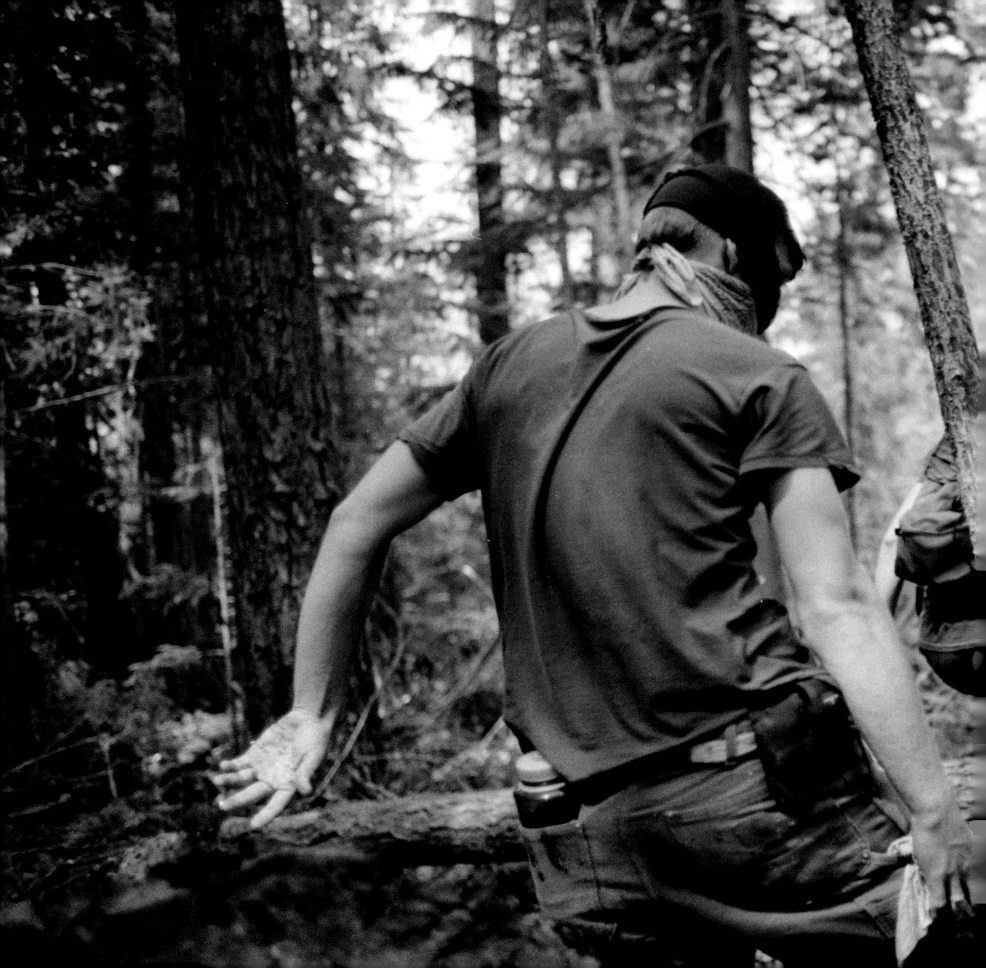

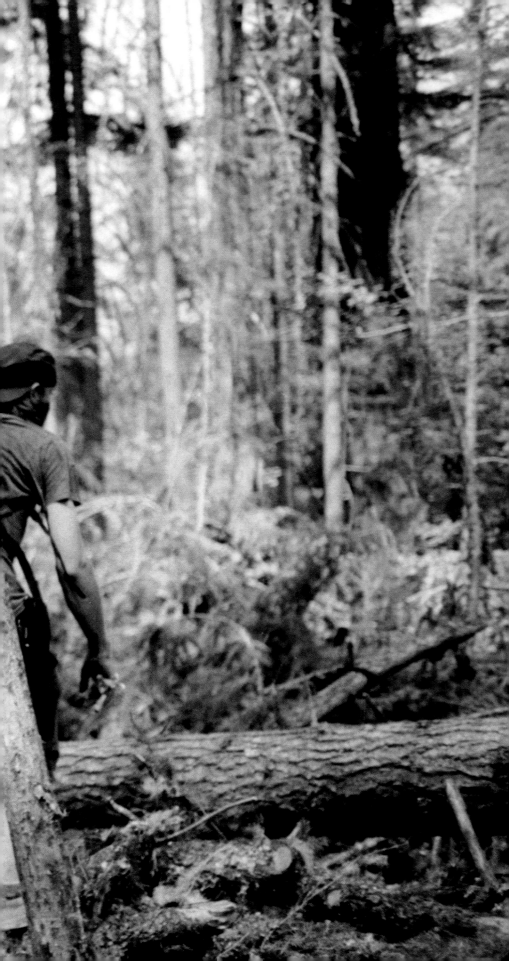

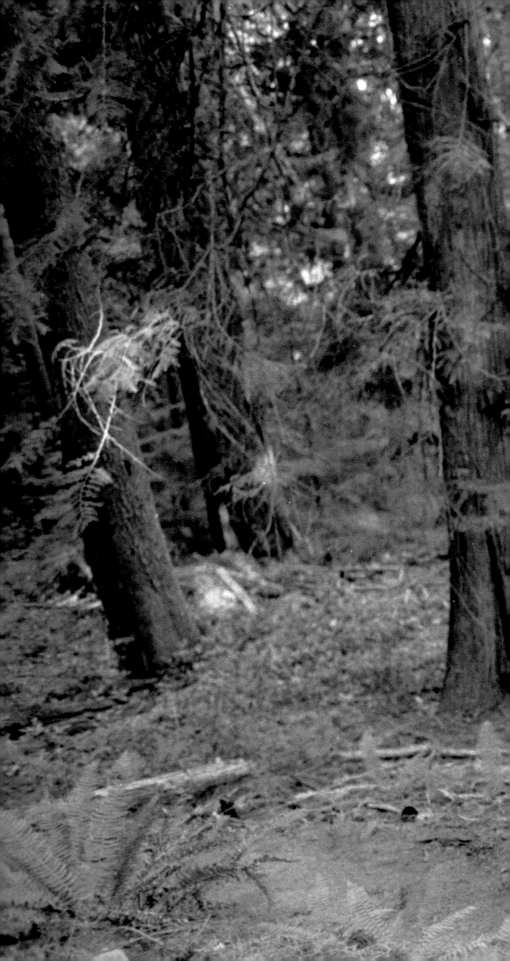

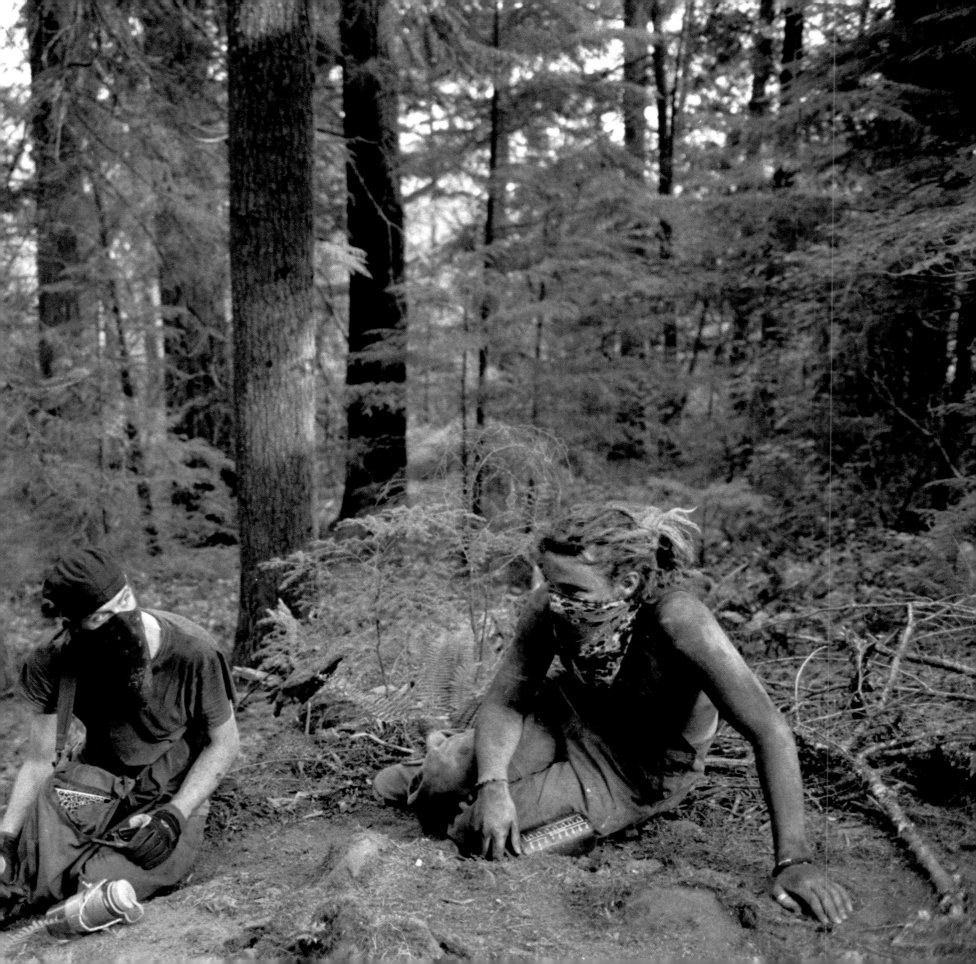

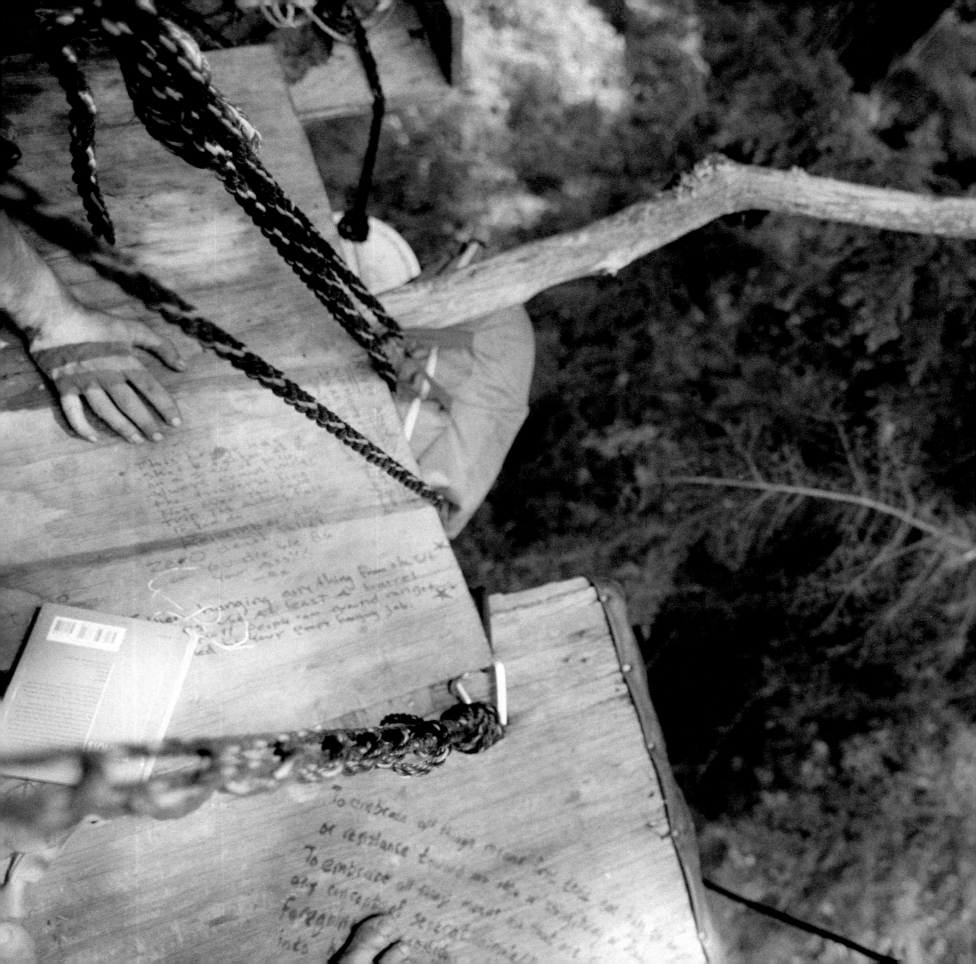

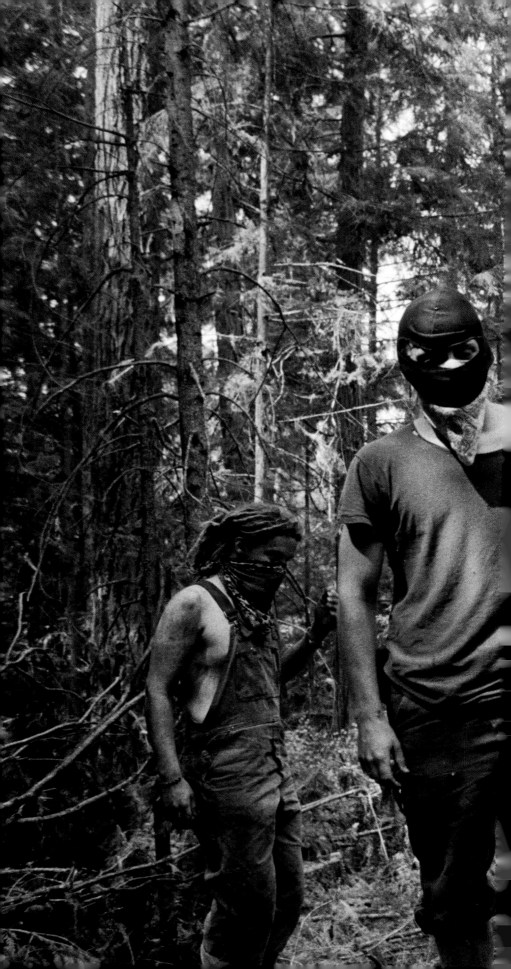

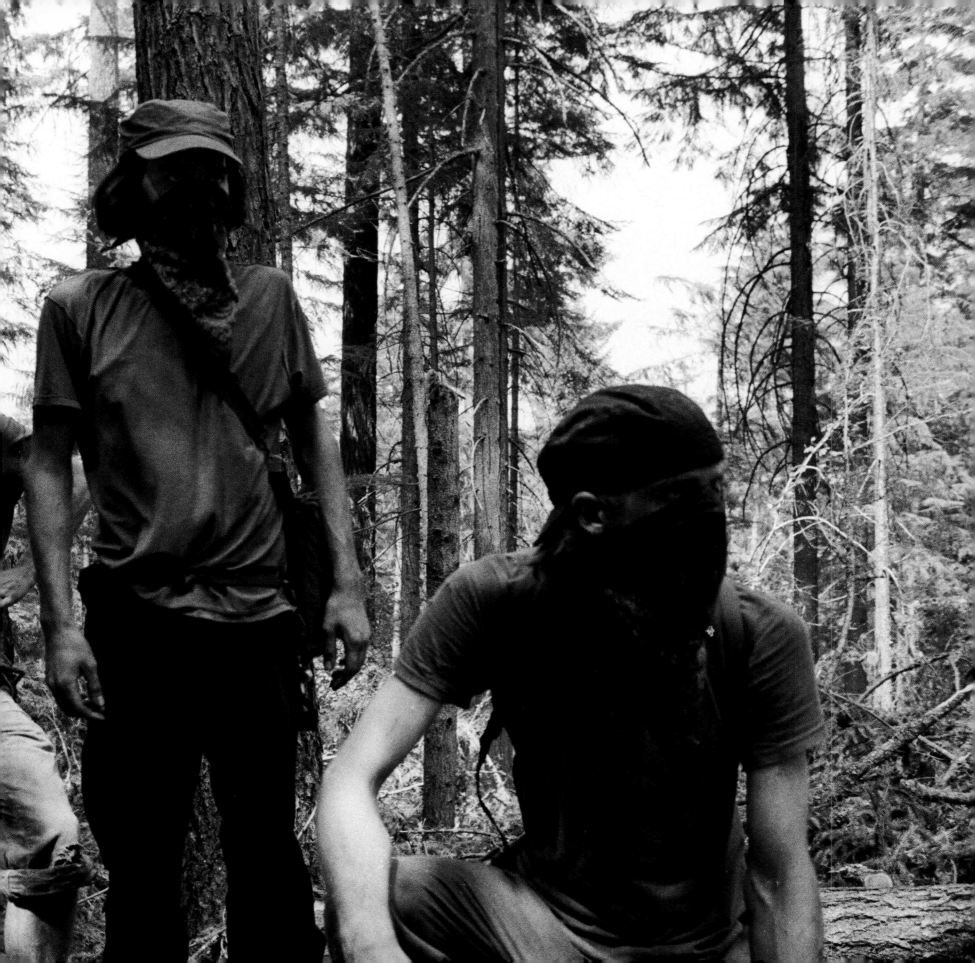

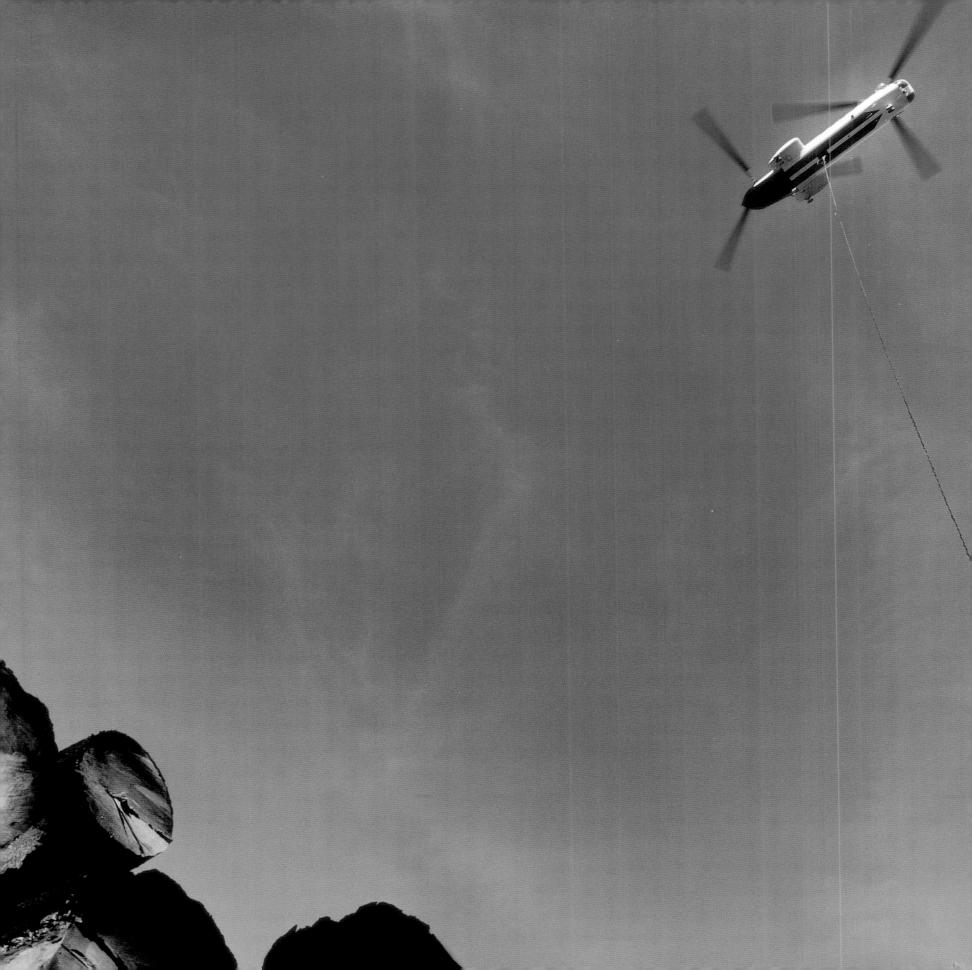

"I have been arrested over one hundred times standing against injustice. Why, I went with the Freedom Riders to the South. I went to Alabama to stop the lynchings. I went to Montgomery, Selma, and Birmingham. I even met Martin Luther King, Jr. The thing we wanted to stand up to back then was the destruction of the diversity of people in this nation; the slavery, racism, and violence towards people of color. The thing we are fighting today is much the same, only we are trying to defend the diversity of the whole world and the life on it." JOAN NORMAN

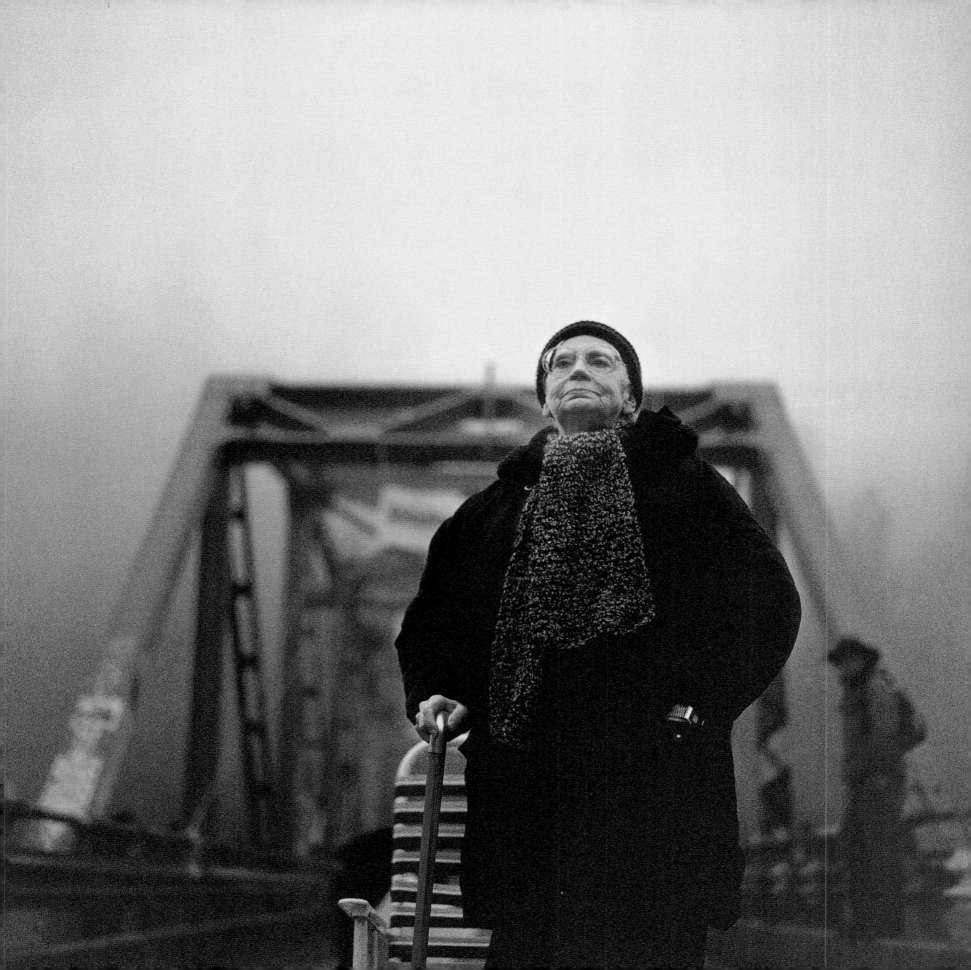

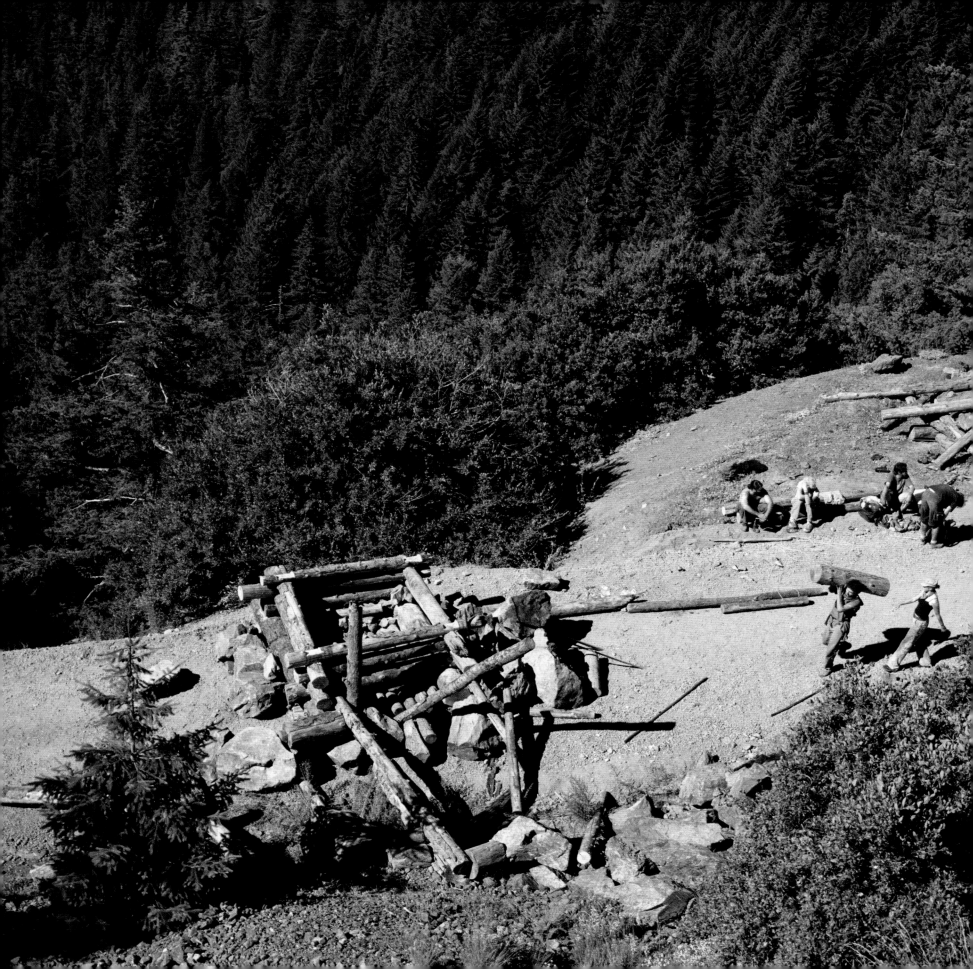

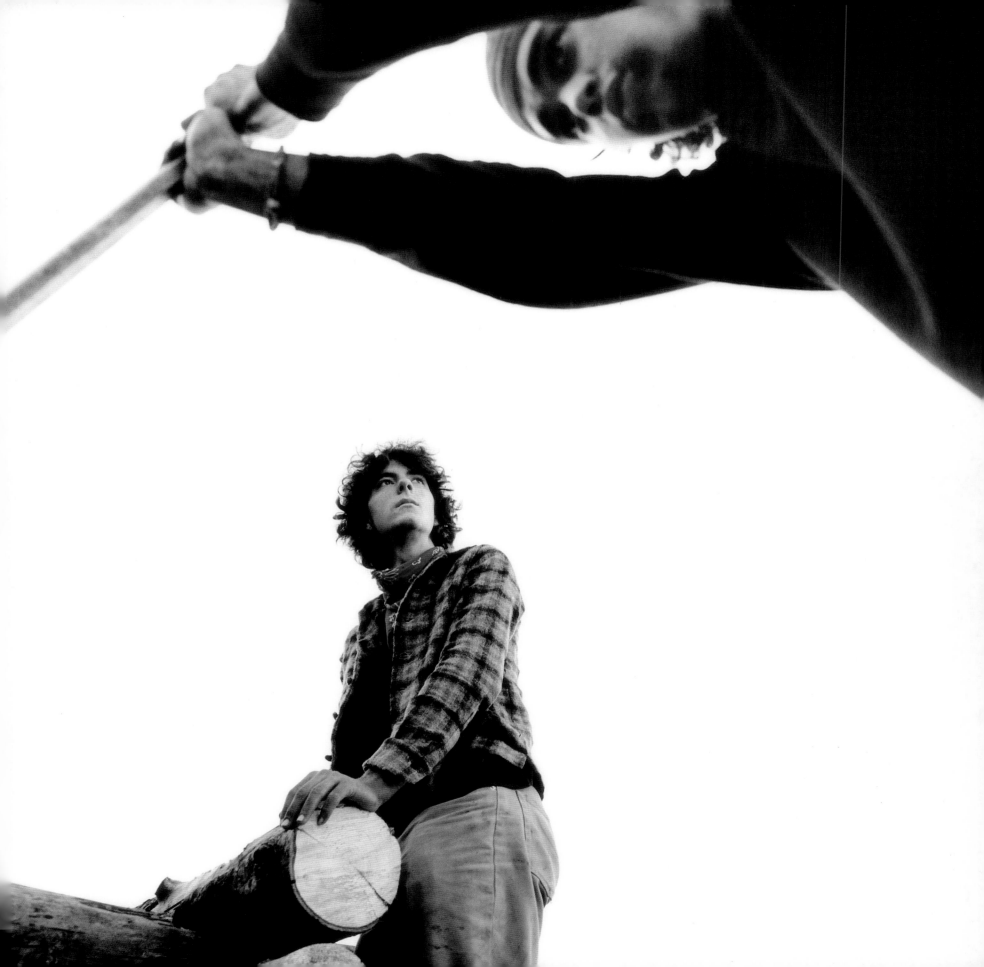

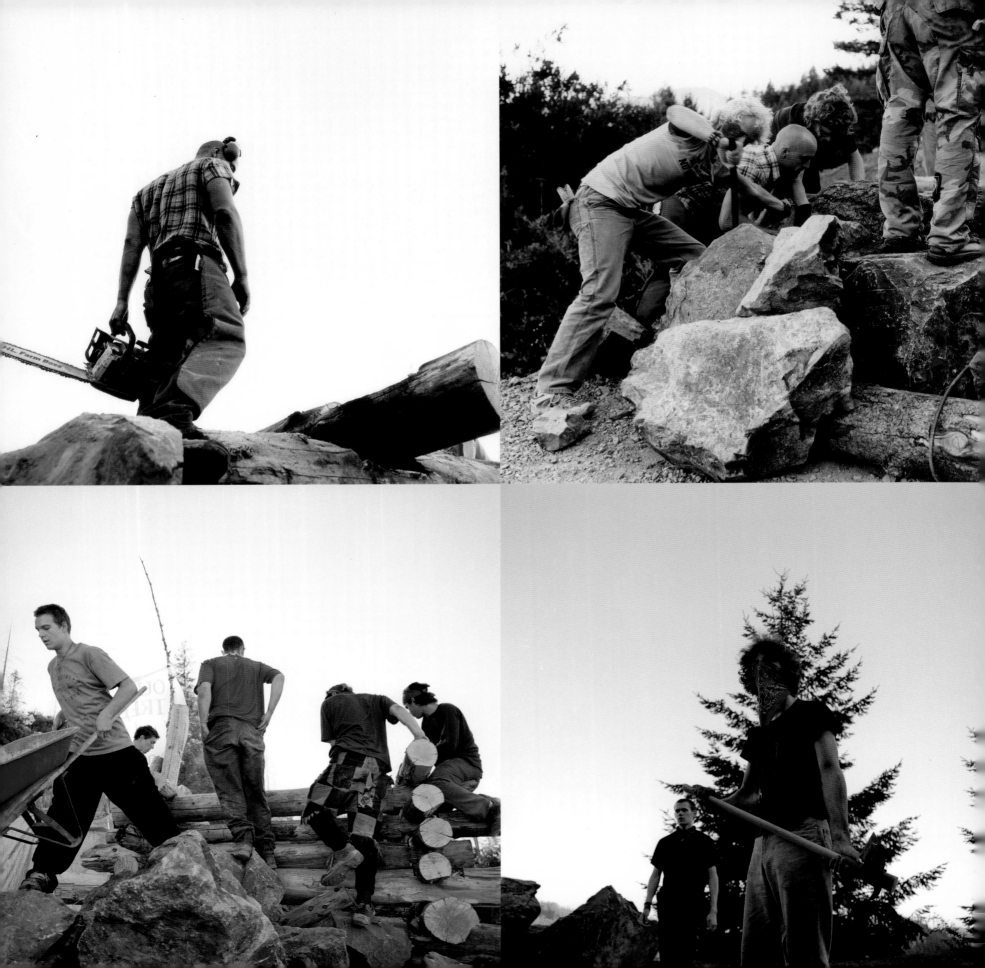

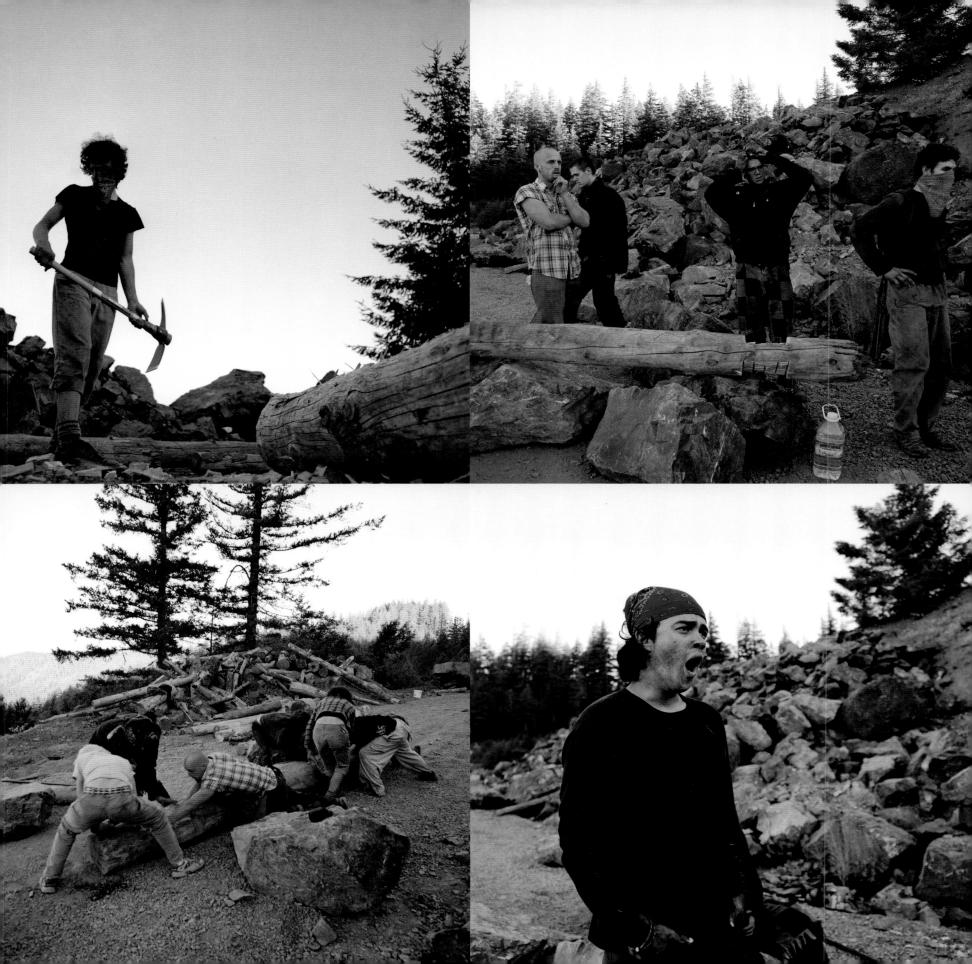

I remember the first time I ever went up into the canopy of an ancient Douglas fir tree. I believe it was about 140 feet up a rope and by the time I got to the top my hands were covered in blisters. I didn't care. The blisters were soon forgotten as I sat down on the old pieces of plywood that hung in silent defiance so far above the forest floor that one had to yell as loud as possible just to be heard by those landlocked mortals still stuck to the ground. If the wind blew, sending ripples of movement through the canopy, then you forgot about communicating with the ground as your words were swallowed by the gentle swishing of the branches. I fell in love. Not with that one tree or that one grove but with the entire forest. The entire global forest and I have spent a good majority of my life trying to protect those places. Slogans like "We must protect our forests" ring hollow in my ears. If someone needs to feel a position of a place to be inspired to protect it, then it's just one more reflection of the shallow and materialist world that would accept such devastation in the first place. We must protect the forests because to do otherwise is just unacceptable on any moral level.

There have been so many moments out in the forest listening to the sounds of distant chainsaws, knowing the next place marked for destruction was the very spot where I stood. There have been so many "timber sales" that I have been a part of trying to stop and to be honest, we don't win very often. It can be cold, wet, and hard work. At times it seems like 80 percent of forest defense is carrying heavy shit up a hill. You have crazy loggers to deal with along with overly macho cops that need to prove their prowess by chasing you through the forest then throwing you to the ground in a pain compliance hold. People don't stick around for long in the forest defense game. People get jaded quickly or perhaps the novelty of it wears off. With every victory being only temporary and every defeat being permanent it is understandable why many people take the easy road of apathy, but there will be those of us that will continue to stand up for the planet. Humanity seems intent on ripping apart the very fabric of life but we will do what we can when we can. We may very well have already crossed the threshold of how much damage the earth can take and still be able to heal itself. I will never give up and accept the razing of every wild place on this planet and the continued disappearance of species after species. I have no choice in this.

I have had the best moments of my life sitting in the crown of a 250 foot tall Douglas fir tree. Just spending time in the forest and waking up every day amongst such beauty makes you understand just how alienating and confining the four walls of a typical bedroom are.

That first tree that I climbed is still standing. After all these years I can still go back and sit under it and remember the blisters and how scared I was. I can be reminded of the moment I fell in love and that love, is what has sustained me along with the anger that is invoked by the sound of every chainsaw being wielded by greed. I want to be remembered as a person who stood up and pushed aside the apathy inherent in the comfort we enjoy as a society. GEDDEN

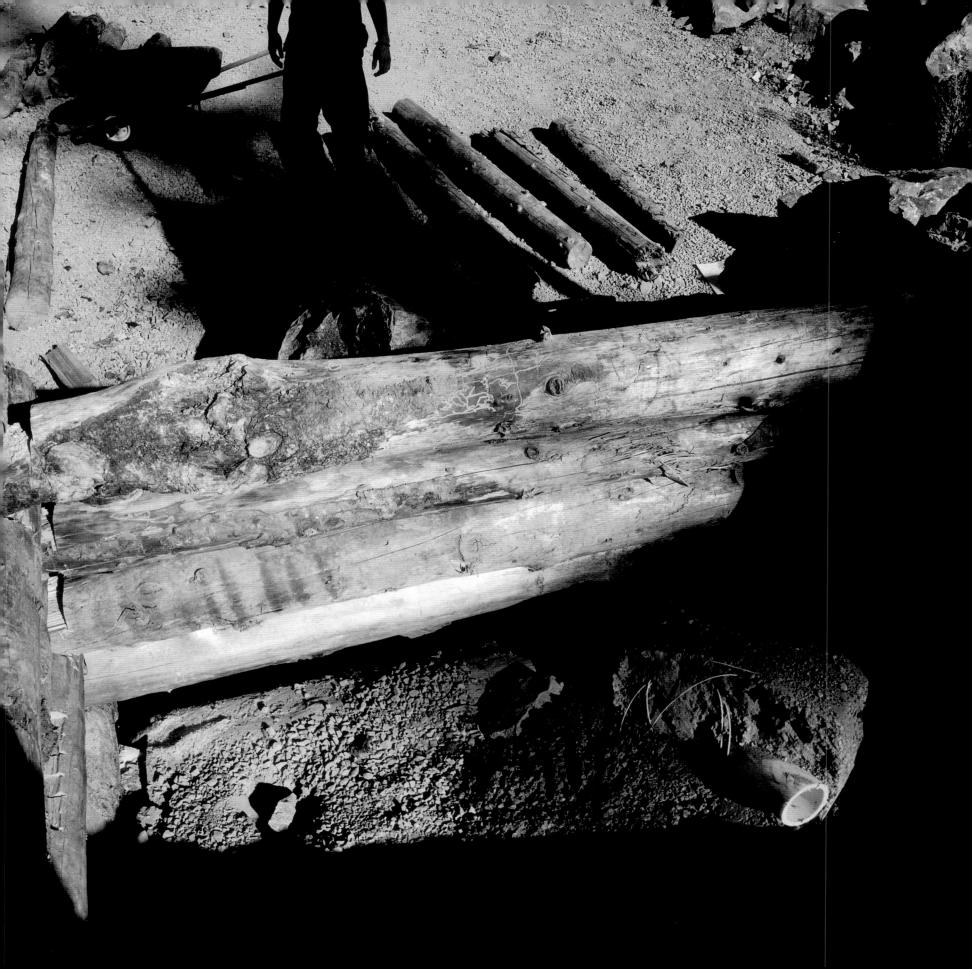

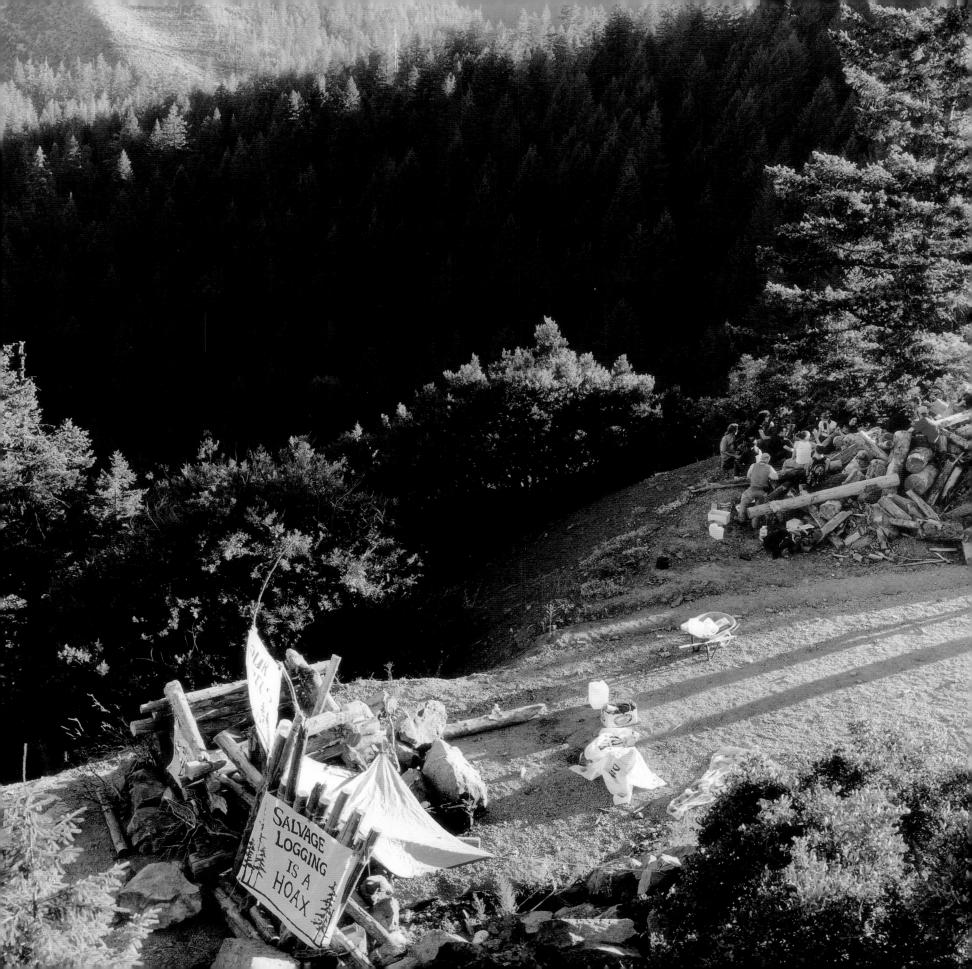

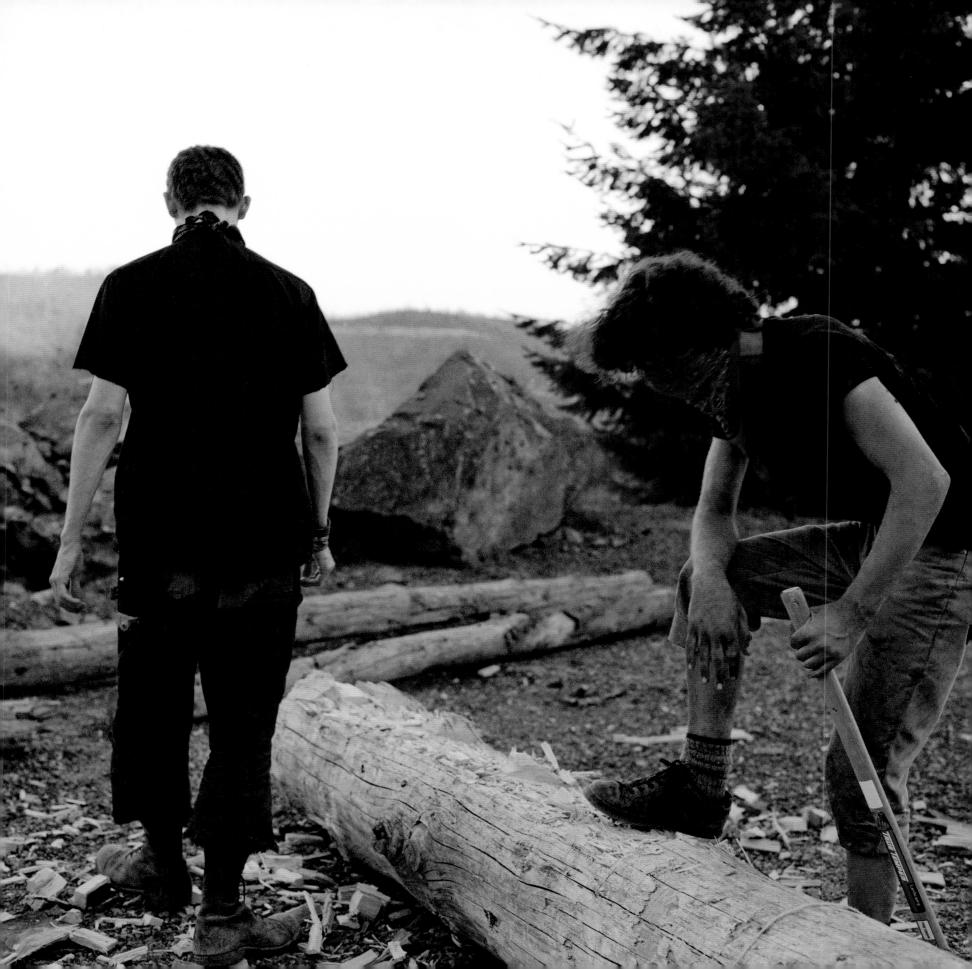

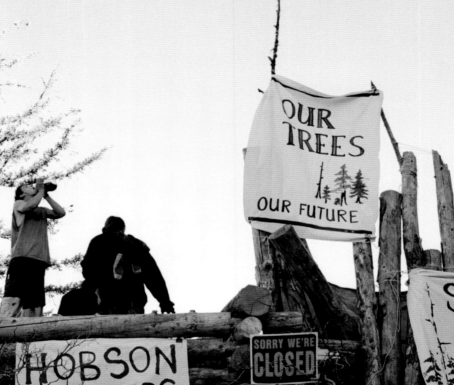

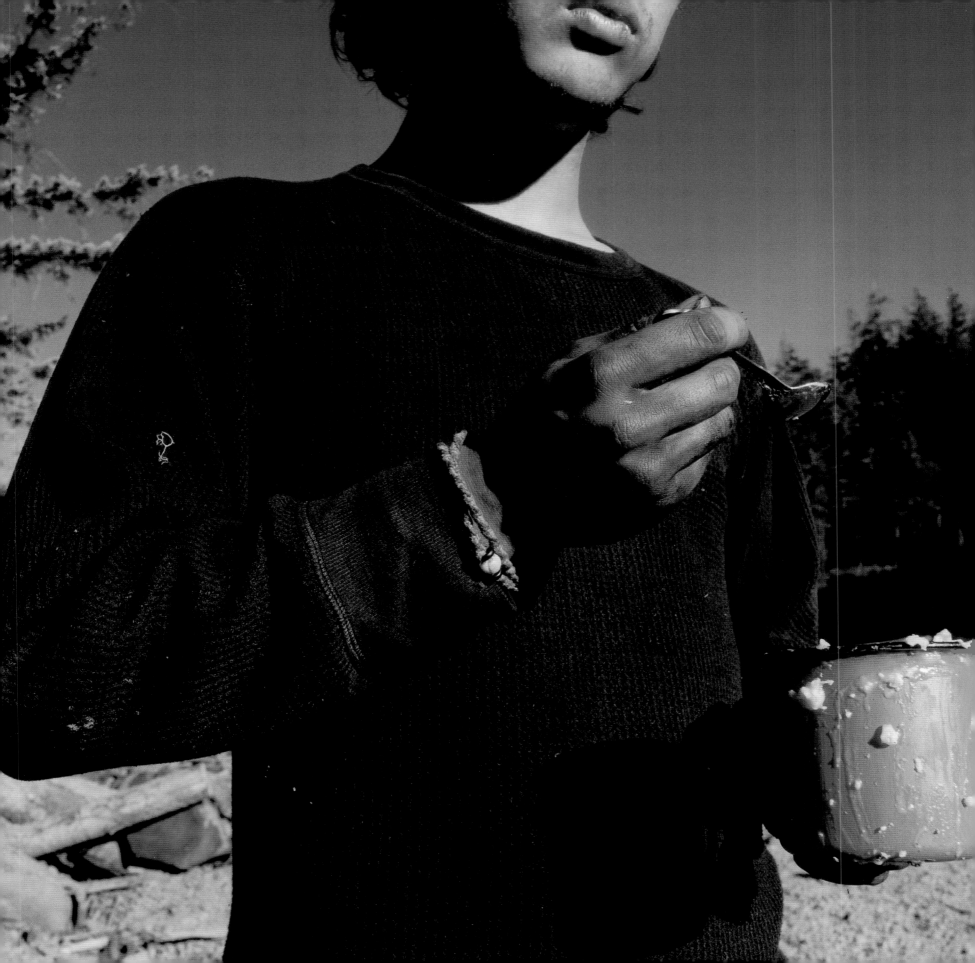

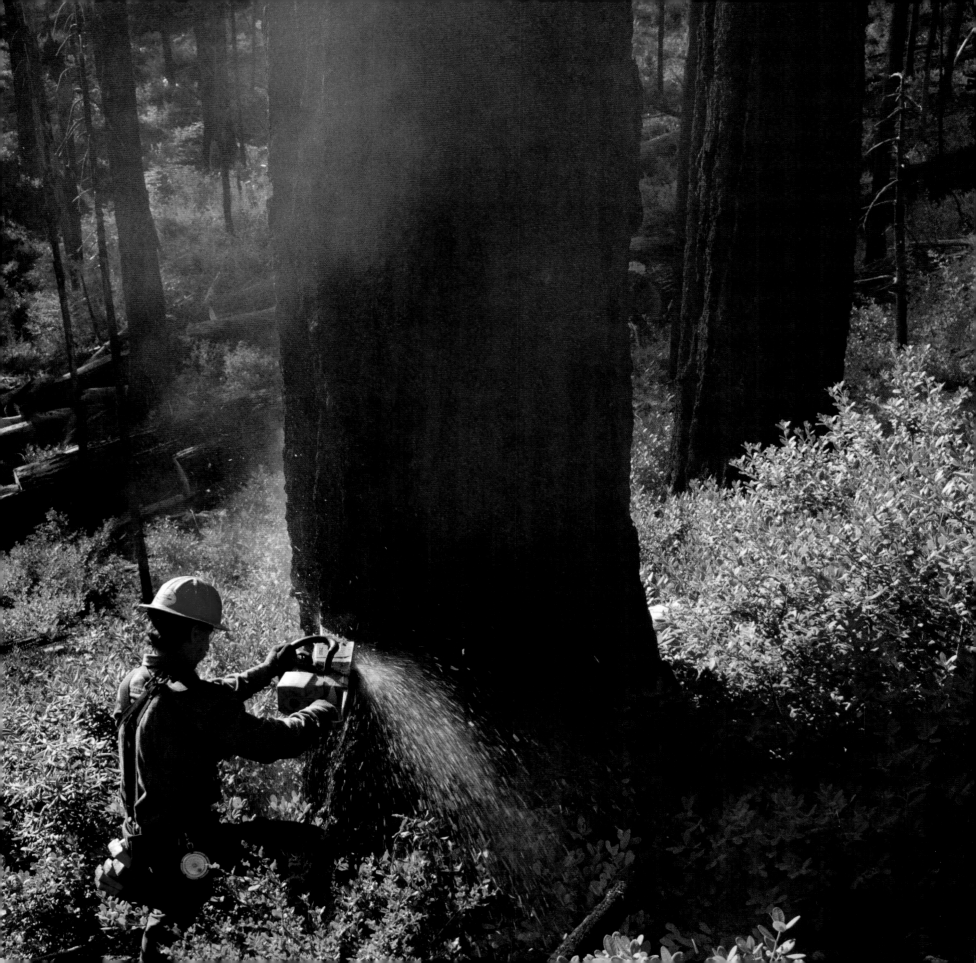

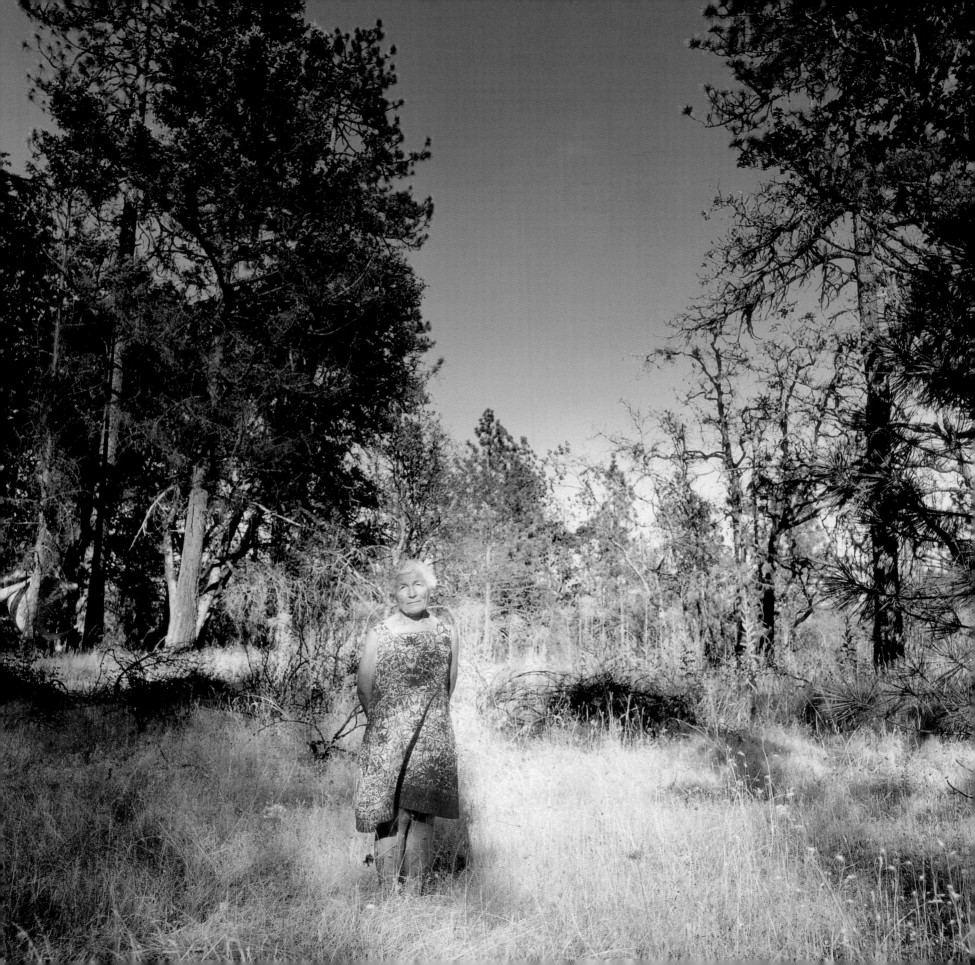

"Using my body to stand up and speak out for the voiceless feels as natural to me as breathing, when I see precious old trees being cut down illegally. It's a matter of conscience, not courage. I want my great-grandchildren to know what it feels like to walk in an ancient forest." DOT FISHER-SMITH

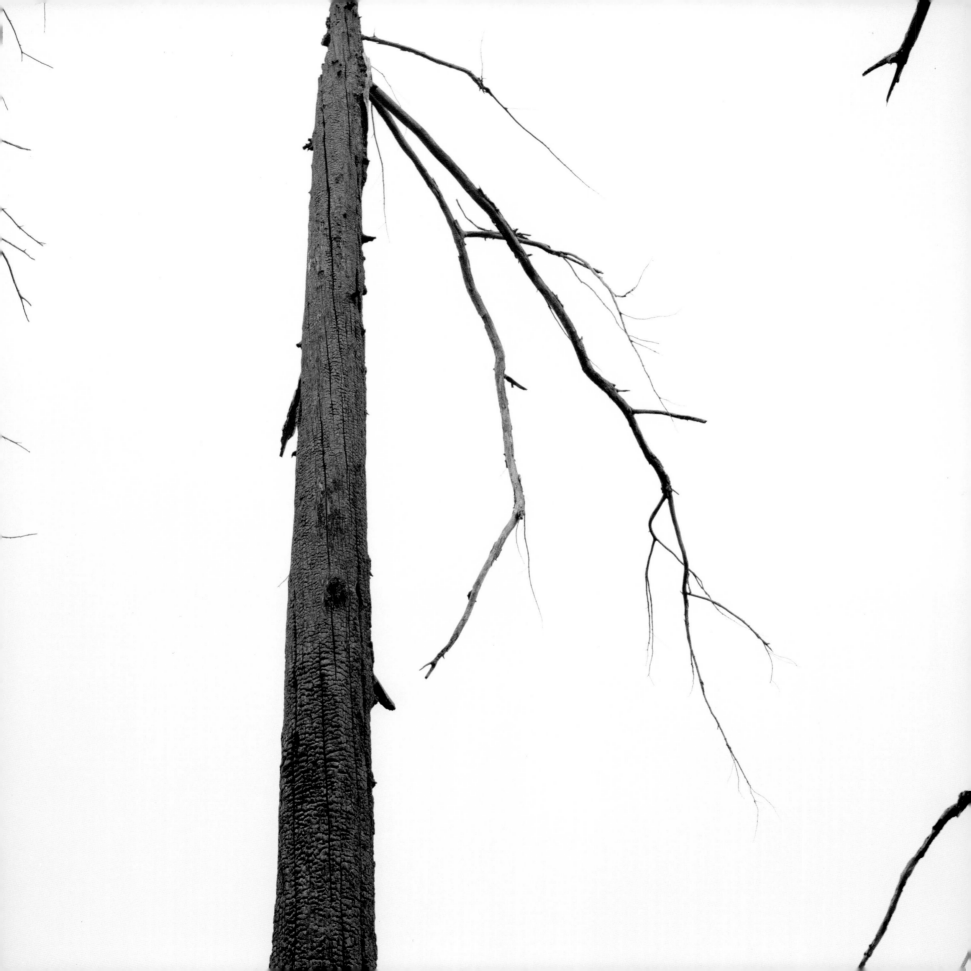

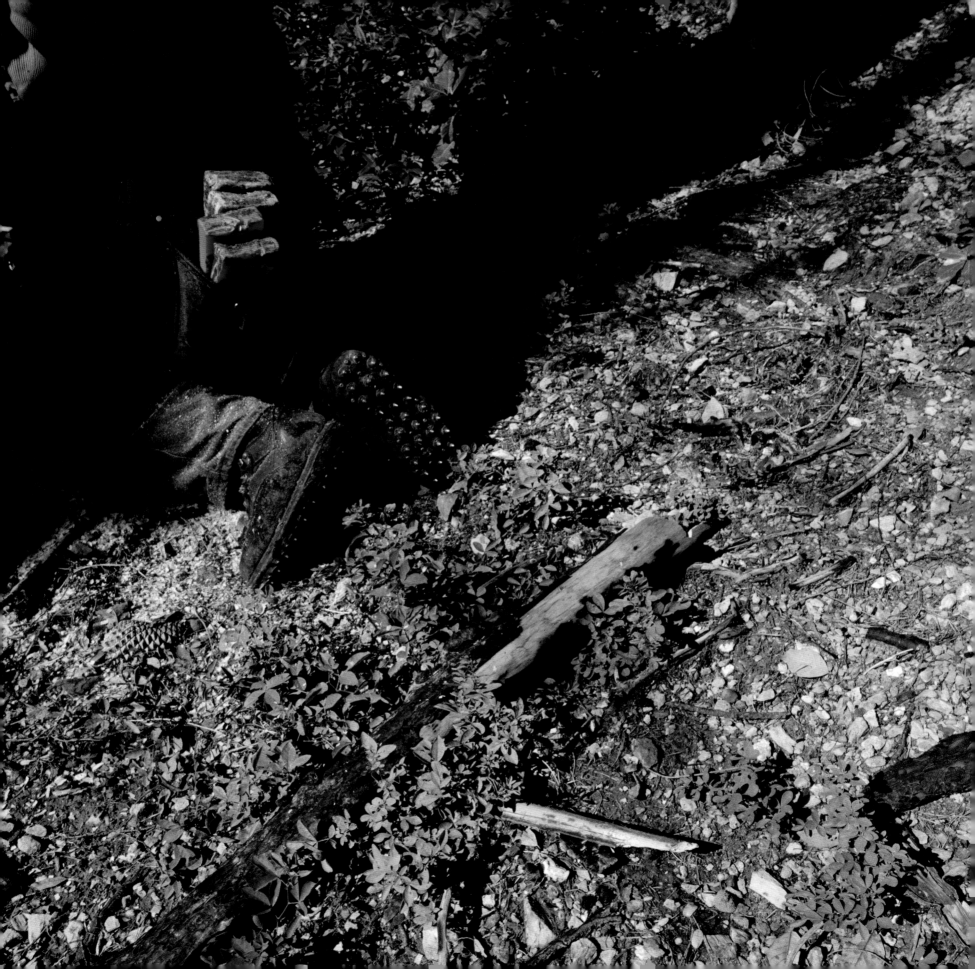

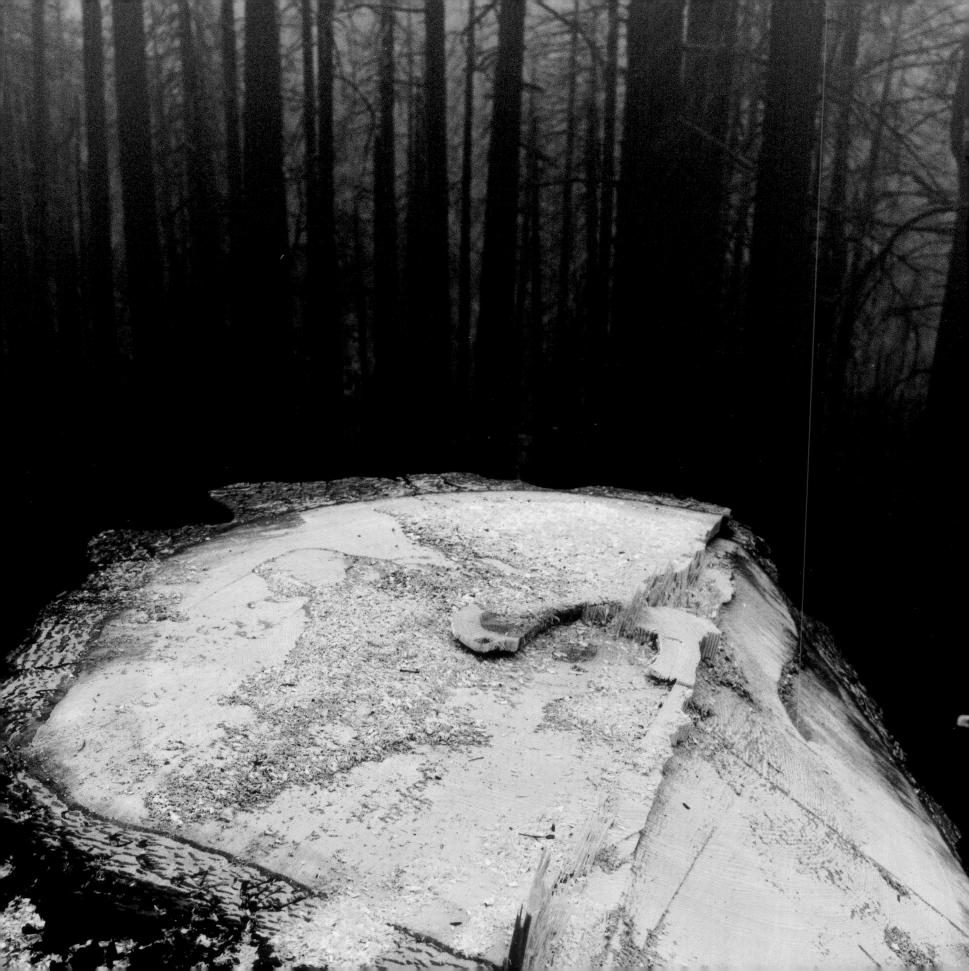

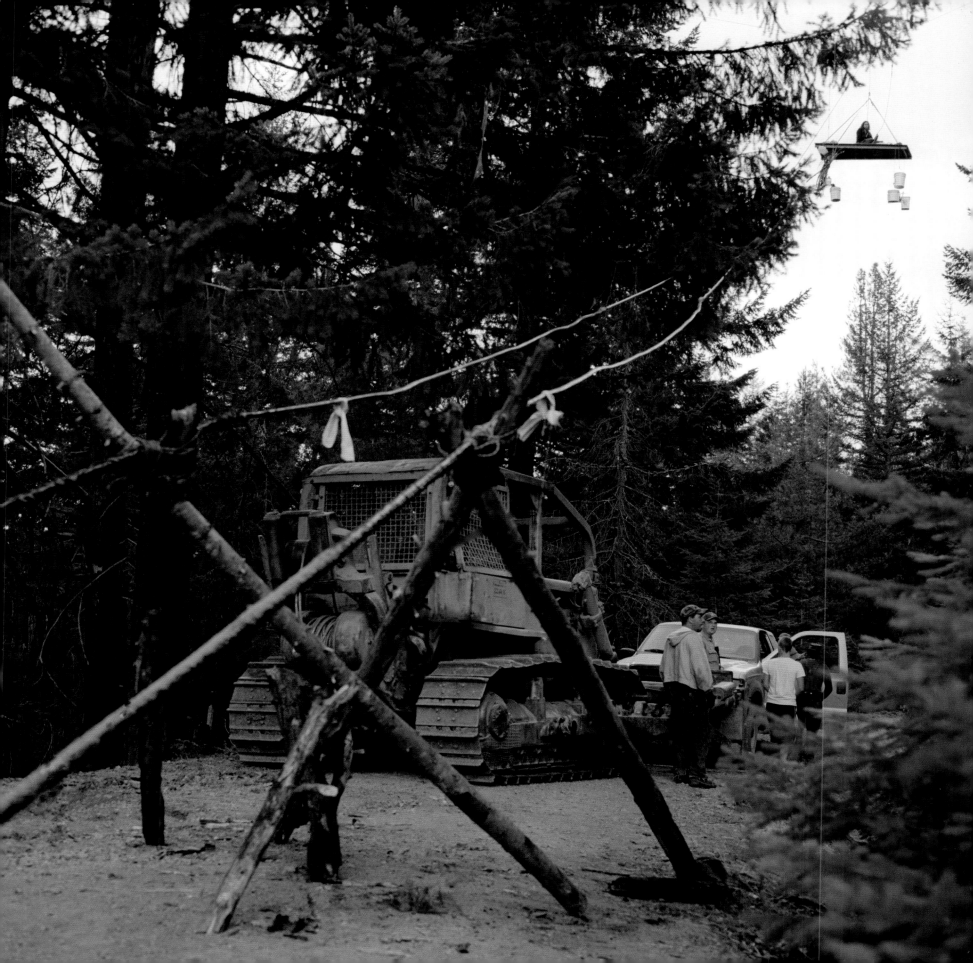

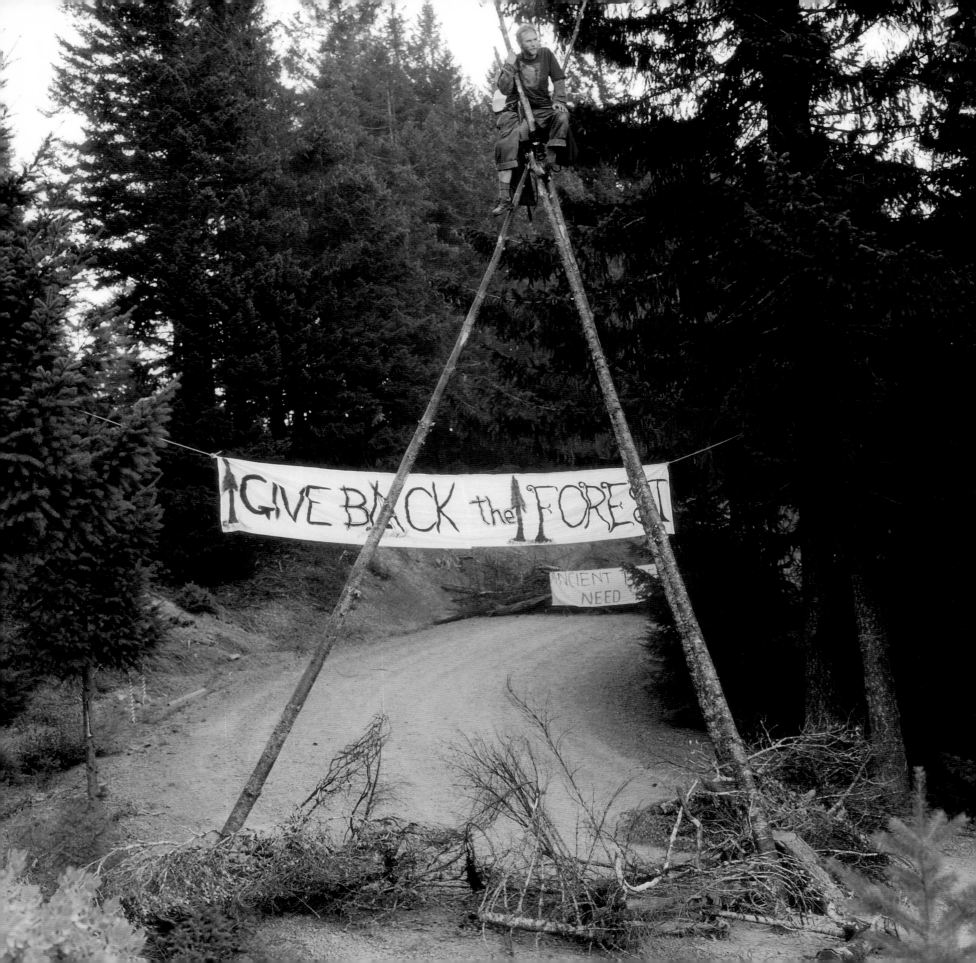

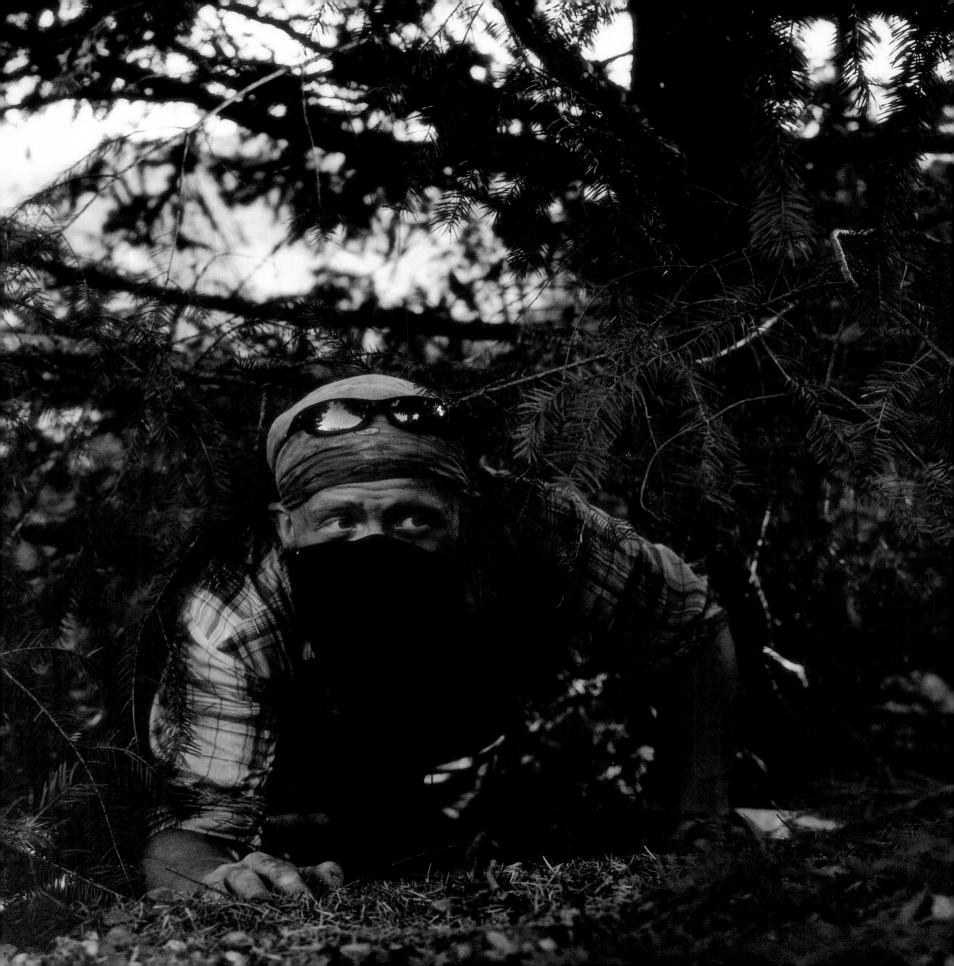

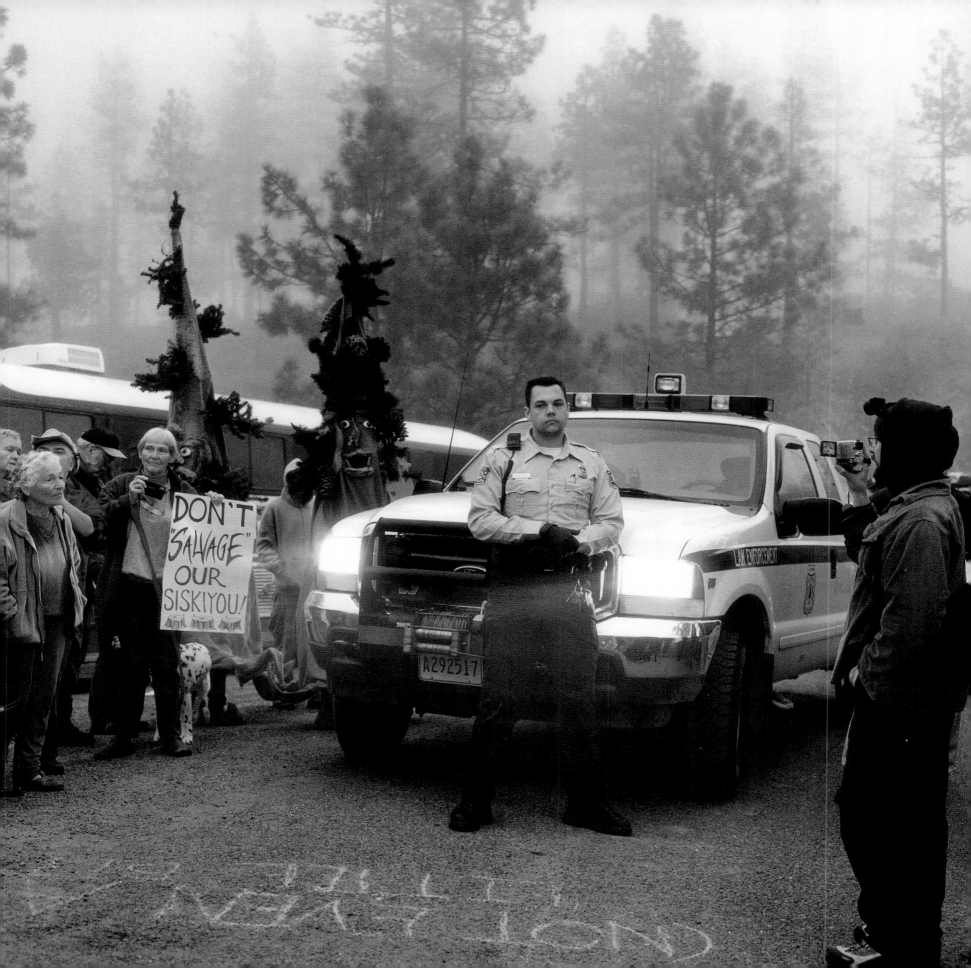

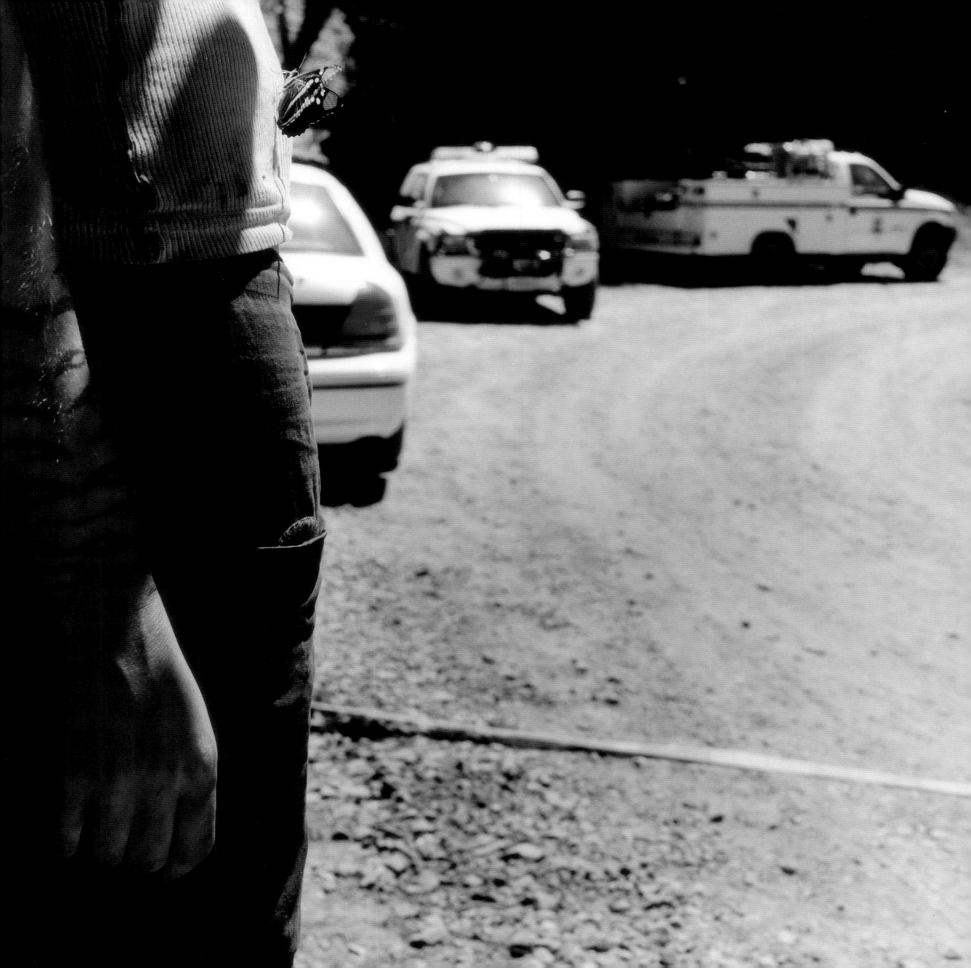

GOING.....
GOING....
GOING......
GOING
GOING
GOING
GOING
GOING....
GOING...

EXTINCTION is FOREVER

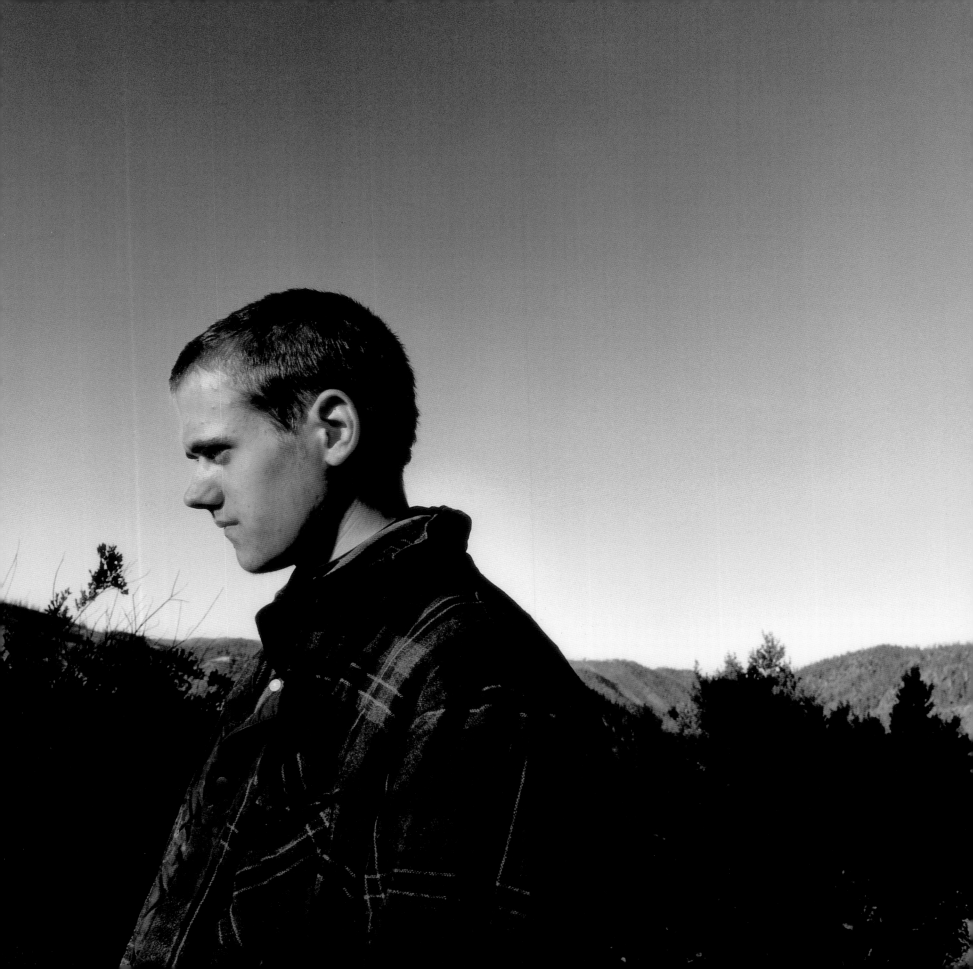

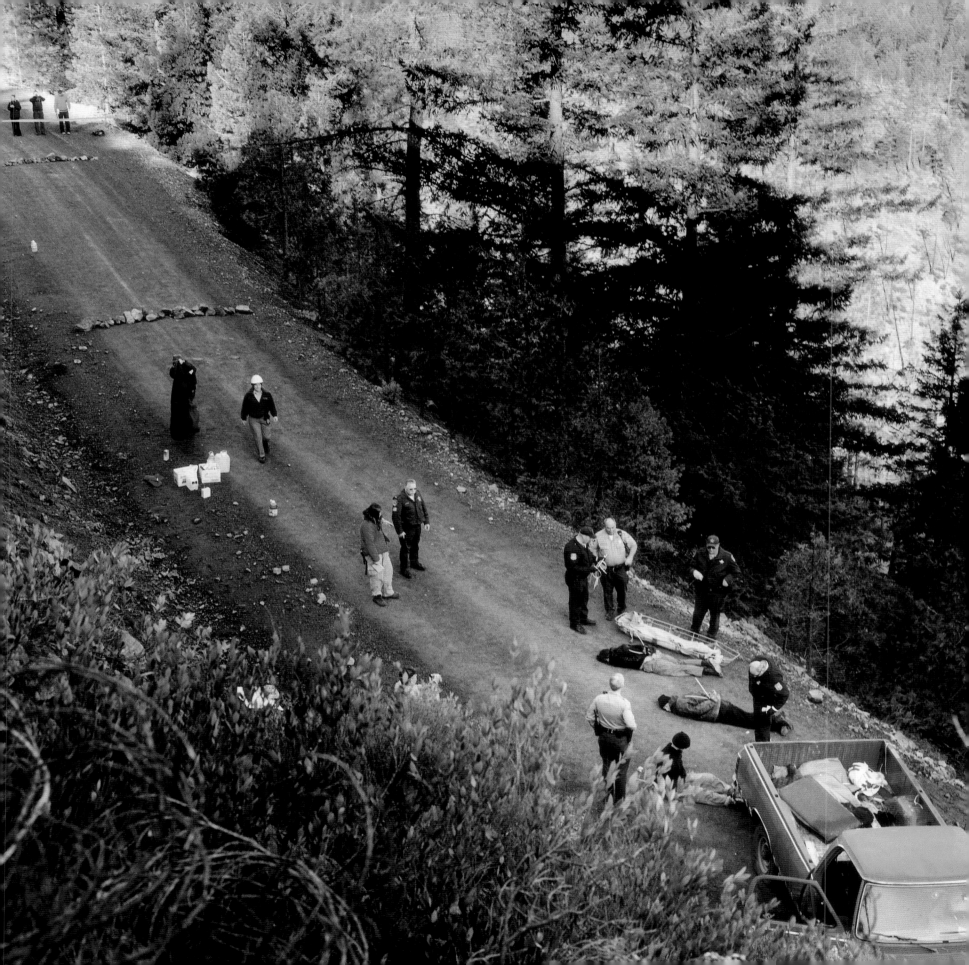

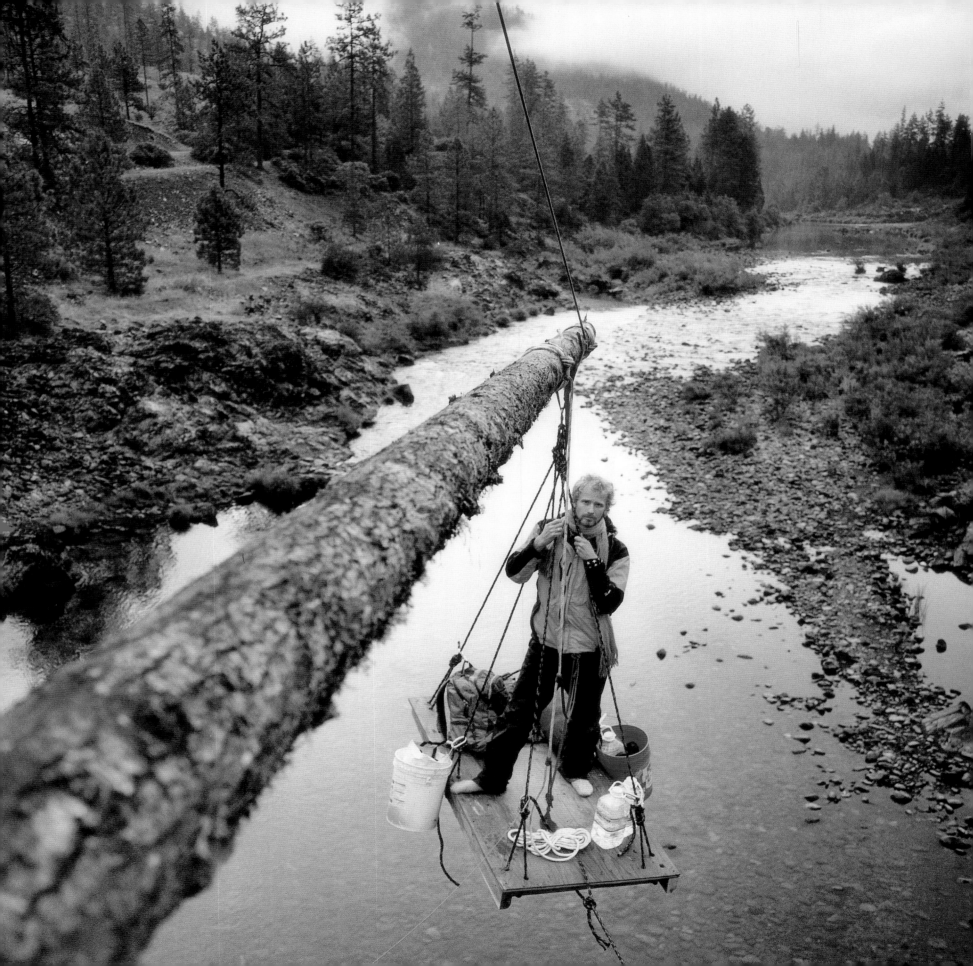

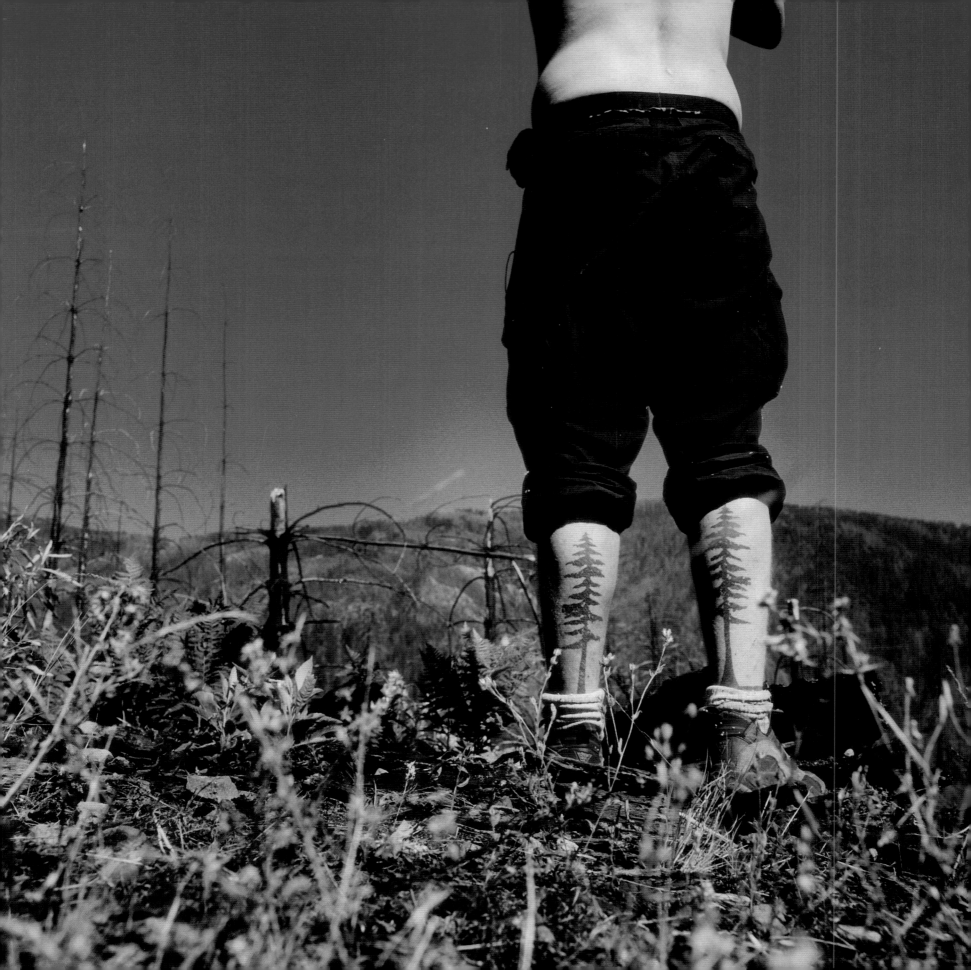

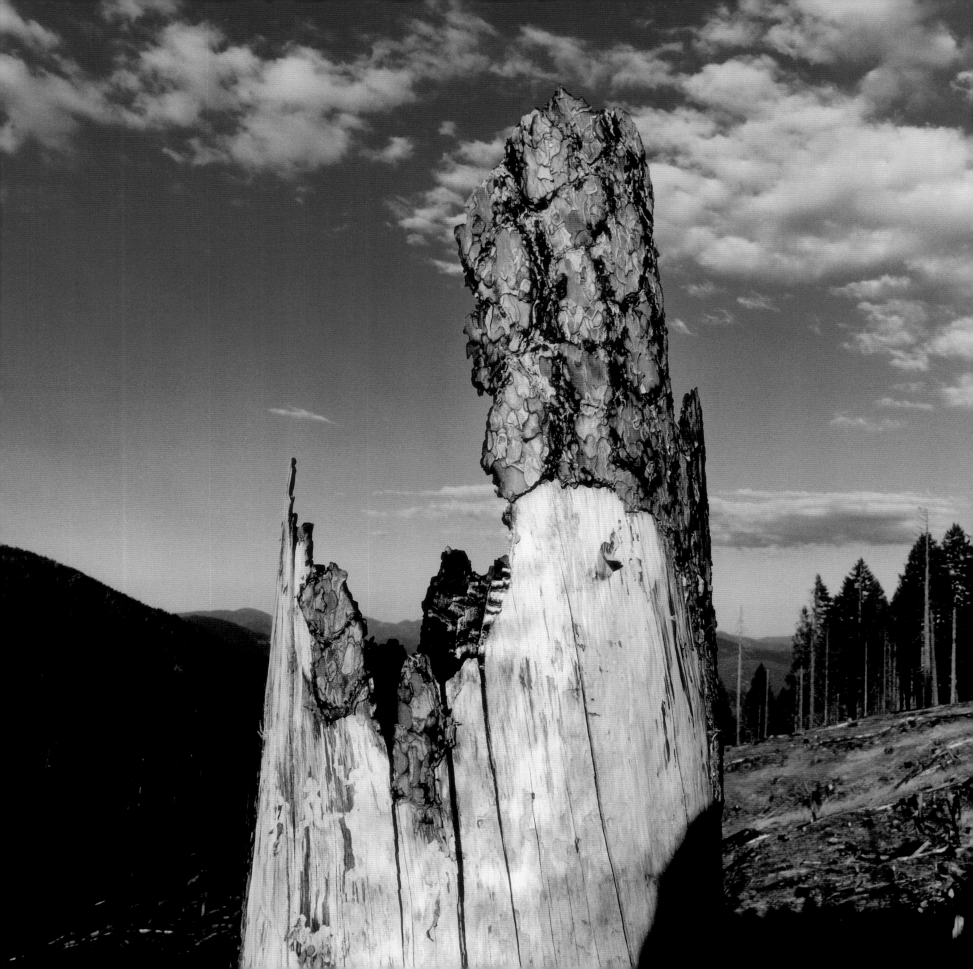

GOING, GOING, GONE.

By any measure, the remaining wild forests of the Pacific Northwest are a small shadow of the forested wilderness that John Muir, the famed first modern preservationist, explored and wrote of in the latter part of the nineteenth century. In Oregon, less than 18 percent of the old-growth forests that existed prior to white settlement still stand. And we are far luckier than most; nationwide less than 4 percent of wild forests in the U.S. remain untouched by the chainsaw. The forests of the Oregon Coast Range are a particularly painful example of industrial forestry run amuck; more than 90 percent of this region has been converted from biologically diverse native forests into tree farms that are planted and logged on "rotations" much like corn. Indeed, many ecologists assert that Oregon's Coast Range is the most severely degraded temperate rainforest on Earth.

The impact of industrial forestry on the communities and watersheds of the Pacific Northwest cannot be overstated. In the Oregon of my youth, sawmills were as common as drive-through coffee kiosks are today. Mills and the ancient forests that sustained them are now a rarity—a throwback to another time. As of 2007, one can count the number of mills that exclusively rely on old-growth timber on one hand. And yet the fight over the last 18 percent of Oregon's old-growth forests is still far from resolved.

ENTER THE NORTHWEST FOREST PLAN: THE COMPROMISERS' COMPROMISE

In the waning years of the first Bush presidency, nonprofit conservation organizations had succeeded in largely shutting down the federal old-growth timber sale program through litigation that listed the northern spotted owl as threatened with extinction due to the widespread loss of its forest habitat. As an old-growth-dependent species, the owl served as a stand-in for the thousands of species associated with ancient forests. It also served as a convenient "straw man" for the debate surrounding old-growth logging on federal lands. For the timber industry, the owl could be blamed for layoffs that were in fact well under way already due to the unsustainable speed at which the national forest had been slicked off in the previous decades and due to the rapid acceleration of mechanization which resulted in the need for far fewer workers to harvest and process ever-larger amounts of wood fiber. For conservationists, the decline of the owl served as a symbol of the region-wide unraveling of public forests and watersheds that threatened to turn the forests of the Northwest into little more than an industrial fiber plantation.

To lift the legal injunction preventing old-growth logging, the Clinton Administration crafted a solution in 1994, known as the Northwest Forest Plan, which was supposed to end the timber wars for once and for all. It was designed to provide the minimum legal level of protection required for the owl while allowing the maximum legal level of old-growth logging. Like many of President Clinton's policy initiatives, the Plan promised to be all things to all people. The timber industry was assured that the Plan would resume the flow of old-growth forests to the mills, while the conservation community was told that the new measure would provide an ecosystem-based management plan that would protect watersheds and old-growth associated species.

Rather than end the timber wars, the Forest Plan simply provided more ammunition for the battle.

THE SALVAGE RIDER SPARKS RESISTANCE

The closest that the Pacific Northwest has ever had to a President (or a King) was Republican Senator Mark Hatfield, who served as chairman of the Senate appropriations committee when the Forest Plan was written and implemented. In a political calculation that was to have enormous impact on the timber wars, Senator Hatfield attached an unrelated "rider" to an interior appropriations bill that contained, among other items, emergency funding to ameliorate the effects of the 1995 bombing of the Oklahoma City Federal Building. The law, known as the "salvage rider," prohibited the public from filing administrative appeals or litigation regarding federal timber sales in the Pacific Northwest during the first two years that the Forest Plan was implemented. In one stroke, the Forest Service and the Bureau of Land Management (BLM) had a blank check to log ancient forests again.

The agencies quickly went to work planning and sponsoring old-growth timber sales throughout the range of the spotted owl. Forest activists labeled this activity, and the salvage rider that insulated them from legal challenge, as "lawless logging" and vowed to resist the sales outside of the courtroom.

The salvage rider, and the subsequent surge of largely illegal old-growth logging, had a profound effect on many people, including myself. Whereas before I had seen the debate over ancient forests as the province of lawyers and experts that unfolded according to a set of rules and laws that had relevance and moral legitimacy, the zeal with which the agencies logged as much old-growth as possible while the courthouse doors were locked to the public convinced me to view the debate over public lands as a moral issue in which the law had become largely irrelevant. If watersheds could be illegally trashed and ancient forest laid to waste regardless of the laws on the books, then the debate must be about more than the content of the law.

I was not the only one for whom the salvage rider was a radicalizing event. Across the Northwest, the debate shifted from the opinion pages and the courtrooms to direct confrontation and resistance in the woods. Following the example of the Earth First! tactics of the 1980s that first brought national attention to the ancient forest struggle, protesters tore up logging roads, locked themselves to bulldozers, and established tree-sits (soon to become tree villages) in old-growth stands slated for logging.

By the time the 1999 World Trade Organization (WTO) protests occurred, as the Seattle Police were to discover, the new wave of the forest defense community had become adept at lockdowns, resisting tear gas and pepper spray, jail support and legal defense, and the organizing and communications that are required for such actions. We had learned the art of resistance while defending the forests.

FIGHTING FIRE WITH FIRE

The most successful of the direct actions challenging the Forest Service's old-growth logging agenda during the salvage rider term occurred at the site of the Warner Creek forest fire in the Willamette National Forest. An arsonist

had intentionally set fire to one of the "protected" old-growth forests designated as a reserve under the Forest Plan. Ongoing lawsuits designed to test the legality of salvage logging the reserve were predictably tossed out of court due to the salvage rider's prohibition against legal challenges. So activists took to the forest and established a road blockade that, to the great surprise of the Forest Service, remained in place on the snowed-in logging road throughout the long, cold Oregon winter. The Warner blockade became the face of the burgeoning forest defense movement and when the proposed timber sale was canceled due to public and political pressure, it became both an example and an icon for forest activists.

The expiration of the salvage rider and the victory at Warner Creek did little to resolve the underlying issues regarding old-growth logging on pubic lands. The Forest Plan still designated nearly a million acres of ancient forests vulnerable to being stripped. And the Forest Service and the BLM still viewed protected areas has unnecessary impediments to logging.

THE BISCUIT FIRE: POLITICS OF THE CHECKBOOK

In 2002, the fire season in Southern Oregon was astounding. The sky was thick with smoke for months as the Biscuit and Timber Rock wildfires burned well over a million acres of forests in the Klamath-Siskiyou and Cascade Mountain Ranges. The forests of Southwest Oregon are not only fire-dependent, they are fire-evolved. One example of this evolution is the knobcone pine, a tree whose cone will open, and seeds germinate, only when touched by fire. Both the Biscuit and Timbered Rock fires burned in mosaic patterns, in which some forest stands were severely burned, while other stands experienced a light underburn, and still other stands were left completely untouched.

As soon as the smoke cleared, the Forest Service and the BLM proposed massive clearcut salvage timber sales in both the Biscuit and Timbered Rock forests. In the Timbered Rock fire, every acre targeted for logging by the BLM was located in a stand that was supposedly off-limits to logging. And in the Biscuit burn, 20,000 out of 29,000 acres that the Forest Service wanted to log were supposedly protected. Furthermore, the Forest Service proposed salvage logging within wilderness-quality "roadless" areas that had recently been protected via the agency's roadless policy, which had been the largest public forest planning process ever undertaken; so large that the Forest Service had received over 2 million public comments regarding the importance that Americans place on these last, best, wild landscapes.

Where the public saw wild forests that evolved in fire and that were protected as reserves under both the Forest Plan and the roadless policy, the Bush administration saw dollar signs. In the 2000 election, the Bush campaign had set a (then) one-day Oregon fund raising record at a timber industry gala in Portland in which over $2 million dollars was raised. And as the 2004 election approached, the timber industry was again pouring money into the Bush campaign.

In the run-up to the election, the Biscuit fire served as the test case to see if the protections of the Northwest Forest Plan and the roadless policy would survive. What happened was that the Forest Service signed the decisions to log the reserves and the roadless forests, numerous lawsuits were filed, protesters protested, and the timber industry cut lots and lots of big checks to their political allies. It was an ugly, depressing political mess.

FIRE IN HER BELLY

In March of 2005, forest activists knew that the old-growth reserves in the Biscuit burn were being logged, but what we didn't know at the time was that trees in an adjacent Forest Service-designated botanical area and acres within the Kalmiopsis Wilderness were also being illegally logged, despite tens of thousands of letters of objection from the public and protests from the Governor.

In an act of grace, at 4:30 AM on March 7, 72 year-old grandmother Joan Norman left home, taking her lawn chair, her glaucoma medicine, and a book of aerial photographs showing the effects of past clearcutting on our National Forests. She then sat in front of the logging truck convoy on its way over the Green Bridge that traverses the Illinois River to continue logging the old-growth reserves in Biscuit. The Josephine County Sheriffs—their uniforms decorated with a shoulder patch illustrating a log truck loaded with old-growth trees—picked up her chair and moved it off the bridge. Without a word Joan returned to her place of resistance in the middle of the road. She was then arrested and lodged in the Josephine County jail where she refused bail. The dignity of her silent stand for the forests was an inspiration that cut through the bitterness and cynical politicking that had defined the Biscuit debate.

Over the next several days dozens of forest activists followed Joan's lead and sat in protest on the Green Bridge, wedging themselves in between the wild forests of the Biscuit and the loggers and law enforcement. By the end of the next week I, too, had been dragged off the Green Bridge and found myself charged with interfering with an agricultural operation, disorderly conduct, and obstructing governmental administration.

My co-defendants and I were not allowed to speak with a lawyer while in jail. We were arraigned via video-speaker while still in the jail. And when I objected that I would not enter a plea until I could speak to council, I was put in solitary confinement. As our hearing approached, the judge told us that we would not be allowed to tell a jury about the timber sale, fire ecology, or why we were arrested on the bridge. Whether it is a trial for nonviolent civil disobedience or a trial to challenge illegal logging, it is clear that the courts do not have the tools and probably the morals to resolve the fight over ancient forests.

Joan Norman died a week prior to her trial, and the supposedly protected old-growth forests in the Biscuit were clearcut. The reserve forests at Timbered Rock were protected (for now). GEORGE SEXTON

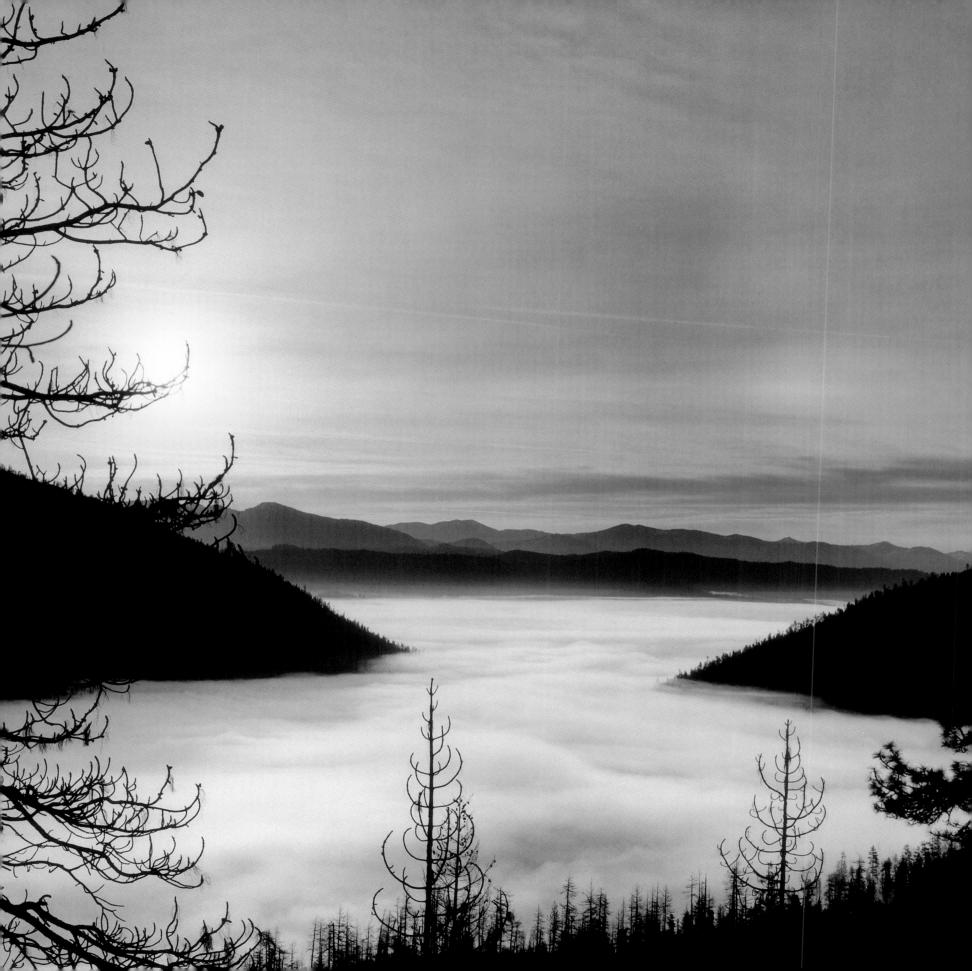

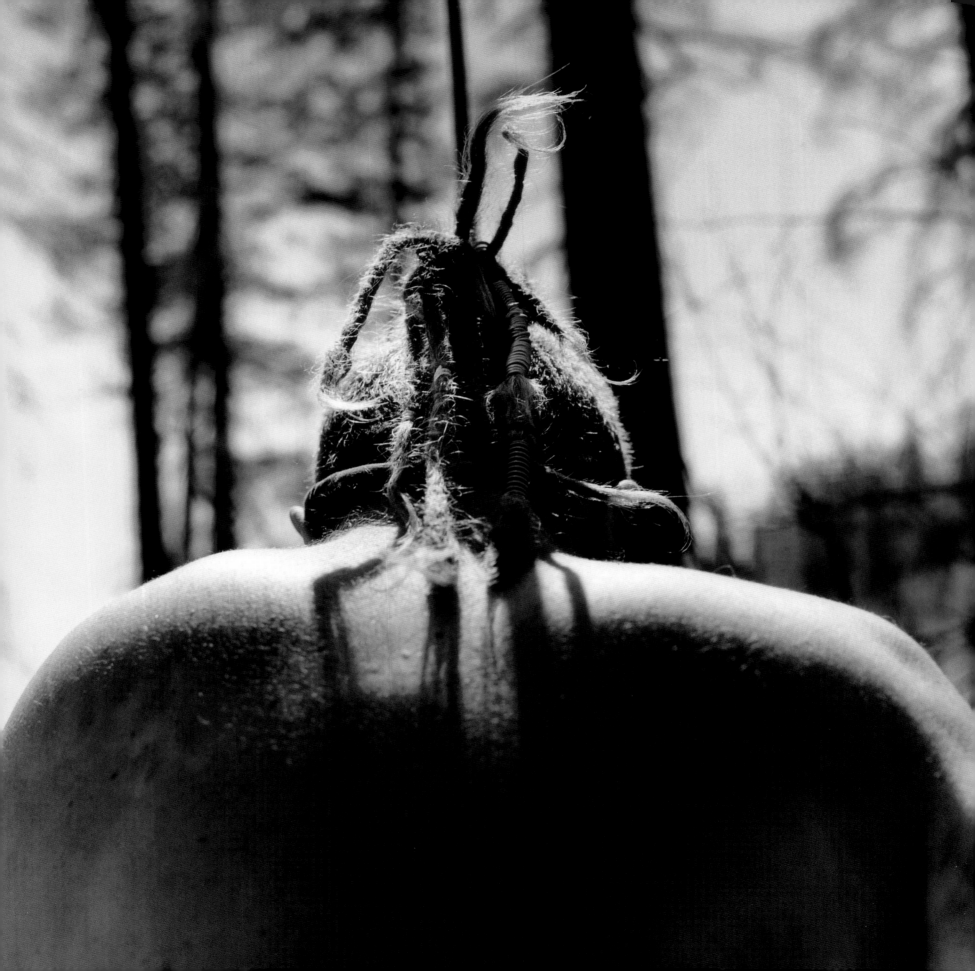

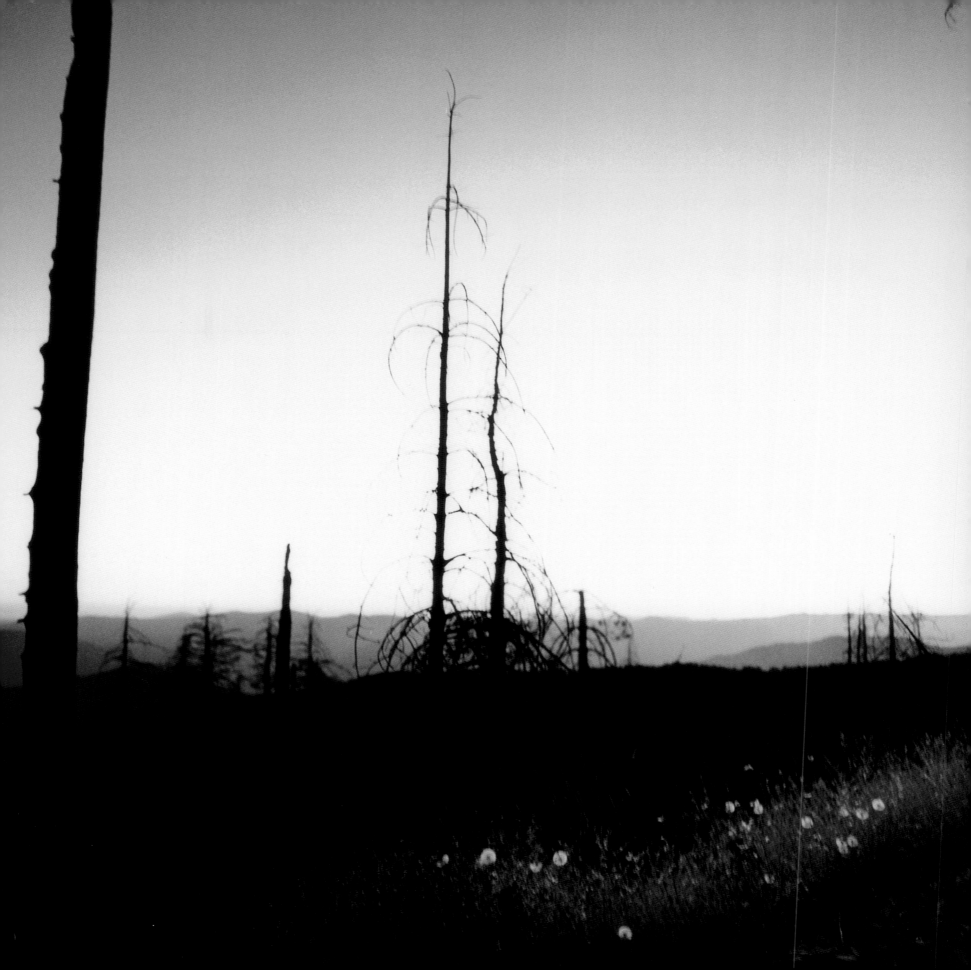

Acknowledgments:

My deepest appreciation goes to Heather Star and Laurel Sutherlin; your trust and openness made this project come alive. To Boones Farm and The Sunday Ranch, if only those walls could talk. Special thanks to Mookie, Usnea, Gedden, Kerol, Rolf Skar, Stu Oneil, Ginger Cassidy, George Sexton, Josh Laughlin, Tim Ream, Lesley Adams, Jeff Hammers, Laura, Nate, and all of the Forest Defenders I have photographed over the years. My deepest gratitude goes to Phil Bicker, who designed and edited this book; your keen sense of space and color has elevated this project. Special thanks also goes to Knox Robinson and *The Fader* Magazine for publishing this work. It's every photographer's dream to walk into a magazine with a personal project and walk out the same day with a ten-page spread. I'm eternally grateful to Stephen Ferry, who taught me the difference between seeing color and feeling color. Maggie Steber, your guidance, openness, and sweetness is beyond my words. Special thanks to Paul Moakley, who has supported my vision and projects over the years, along with Elisabeth Biondi, Anthony LaSala, Sabine Meyer, Nancy Iacoi, Sadie Quarrier, and Joanna Lehan. Special thanks also goes to my agents Marcel Saba and Jasmine DeFoore, who never questioned me going into the forest "one more time." None of this would have been possible without the laughter and love from my Eugene family, Kay and Howard. Thanks to Bob Paradise for opening his doors in San Francisco, along with Dave Shaftel, David Cashion, and Elizabeth Royte for their editorial input. I'm forever grateful to my fellow photographers Johan Spanner, Kathryn Gamble, Jessica Dimmock, Clay Patrick McBride, and Andrew Lichenstein. A special thank you to Craig Cohen at my publisher, powerHouse Books; your passion from day one has been incredible. I'd like to also thank the International Center of Photography, Redux Pictures, and *Photo District News*. Lastly, thanks to my family for their unconditional love and support.

Forest Defenders
The Confrontational American Landscape

© 2008 powerHouse Cultural Entertainment, Inc.
Photographs © 2008 Christopher LaMarca
Texts © 2008 Usnea, Jeff Hammers, Gedden,
Joan Norman, Dot Fisher-Smith, George Sexton

Published in the United States by powerHouse Books,
a division of powerHouse Cultural Entertainment, Inc.
37 Main Street, Brooklyn, NY 11201-1021
telephone (212) 604-9074, fax (212) 366-5247
e-mail: forestdefenders@powerHouseBooks.com
website: www.powerHouseBooks.com

First edition, 2008

Library of Congress Control Number: 2007943712

Hardcover ISBN 978-1-57687-428-8

Printing and binding by Midas Printing, Inc., China

The paper used in the production of this book was made from trees grown in
independently inspected forests, and certified as meeting the highest standards
for environmental, social, and economic responsibility.

Book design by Phil Bicker

A complete catalog of powerHouse Books and Limited Editions is available
upon request; please call, write, or visit our website.

10 9 8 7 6 5 4 3 2 1

Printed and bound in China